LAURIE LEE

COUNTRY

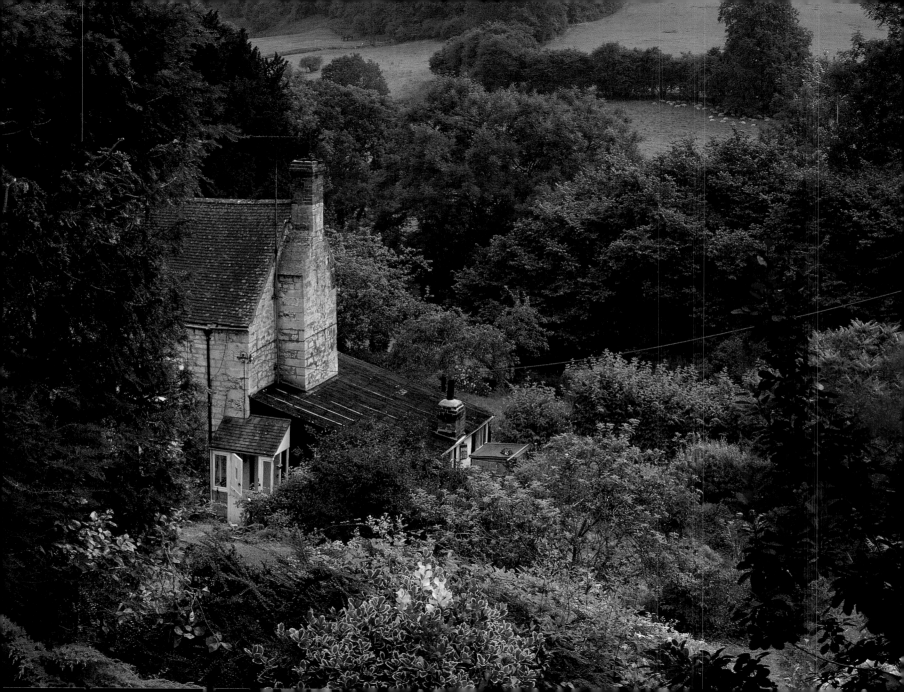

LAURIE LEE
COUNTRY

—

PHOTOGRAPHED BY PAUL BARKER
COMMENTARY BY JAMES BIRDSALL

PAVILION

First published in Great Britain in 2001 by
PAVILION BOOKS LIMITED
64 Brewery Road, London N7 9NT

A member of the Chrysalis Group plc

Text copyright © James Birdsall 2001
Photographs copyright © Paul Barker 2001

Designed by Nigel Partridge

The moral right of the author has been asserted.

A CIP catalogue record for this book is available from the British Library.

ISBN 1 85793 439 8

Colour origination by Classic Scan Ltd, Singapore
Printed and bound by Kyodo Printing Company, Singapore

2 4 6 8 10 9 7 5 3 1

This book may be ordered by post direct from the publisher.
Please contact the Marketing Department. But try your bookshop first.

Frontispiece: Rose Bank.

CONTENTS

DEDICATION

To George, Daniel, Claire, Leanne and Rachel, children of the new century, in the hope that enough of the world of these pages will survive for them to cherish.

ACKNOWLEDGEMENTS

The author would like to thank Kathy Lee and her agent, Patricia Kavanagh, for their kind permission to quote Laurie Lee's prose and poetry so extensively. Without Patricia's early encouragement this book and others would probably never have been written. He also owns his indebtedness to Valerie Grove's *The Well Loved Stranger*, without which whole, this small part would have been hopelessly out of context. Thanks also go to the BBC for permission to quote from a Radio 4 interview Christopher Cook conducted with Laurie Lee in 1988.

PREFACE

Introducing a collection of his own comic verses, or 'clerihews', E.C. Bentley wrote,

The art of Biography
Is different from Geography.
Geography is about maps,
But Biography is about chaps.

This book, however, is really as much map as chap, as much about the Gloucestershire countryside as it is about Laurie Lee himself – a mixture of geography and biography. Anyway Valerie Grove has already written the definitive Lee biography, *The Well Loved Stranger*, for which masterly work I am unashamedly grateful.

Most people are familiar with *Cider with Rosie*, Laurie Lee's account of his boyhood in rural Gloucestershire between the wars. His poetry may not be so widely known, but, like the book, most of it is pastoral. Not the pastoral of Watteau or of Wordsworth, but of the earth, earthy: a countryside with smells.

So much of Lee's early life mirrors my own childhood, spent two decades later in a dog and stick farmland which wartime scarcities had virtually plunged back into a rhythm and way of life that had hardly changed for centuries. Squire and parson, ploughland and stubble, haycart and harvest, fête and funeral, village school and village pub, church choir and church concert, brazen sunshine and burst pipes – all of these had their allotted place in the order of things.

Bits of all this still remain in and around Slad, the Cotswold valley village where Lee grew up, but country villages evolve as farming practice becomes ever more mechanized and manpower-saving; barns are 'converted'; terraced cottages are knocked through to make one; the old workforce has long been redundant and their descendants have largely moved away. Lee himself warned that, 'Soon the village would break, dissolve and scatter, become no more than a place for pensioners'. Happily, however, Paul Barker's selective lens has the magical power, not to re-create the years between the world wars, but to present a pastiche which might easily persuade the reader that the past is still with us.

Laurie Lee himself came back to the Cotswolds to live and remained there into old age. 'That place is still my home,' he wrote, 'in spite of all these years. And the reason is the obstinacy in the blood. I come from generations of Cotswold farmers. I have inherited instincts that are tuned to pastoral rhythms, to the

moods of the earth, to seedtime and harvest, and the great cycle of the seasons ... and I, for my part, cannot lose them.' Traces of the early muse still survive in his valley and hills, the bucolic cradle, by turns lush and harsh, which formed his stimulating Helicon up to the day when he 'walked out one midsummer morning', taking his fiddle with him.

This book, then, is about Laurie Lee's country and the seasons. That it is also about a man, an acute observer, poet and naturalist is almost incidental. The commentary is his, although borrowed for the occasion, but the subject is the Cotswold landscape and the seasons. In England we talk about the weather. In England we have talked about the weather for the past millennia, ever since the first hunter-gatherer scraped his first terrace and planted his first crop. Today, however, a cold, wet summer may simply occasion discomfort and a leafing through gaudy brochures for escape to sunnier climes. During our man's childhood it could spell disaster and starvation for man and beast. But heavy snowfall, for example, was expected in its season, a regular hazard provided for and stoically surmounted, in contrast to the surprised panic and dislocation brought about by a few inches in our enlightened island today.

The edges of the seasons seem to have blurred over a lifetime. Even in the countryside, spring, summer, autumn and winter appear to have merged. Strawberries, once a summer treat, now gain in year-round availability what they have lost in flavour. Mushrooms, blind, anaemic, are continuously forced in dark mines, no longer trophies after a warm night's dew on misty September mornings. Centrally heated and air-conditioned, car-borne and cosseted, we have cocooned ourselves from the elements and the rhythm of the natural world, and perhaps subconsciously feel an inner disquiet. It is significant that on the best occasion of the year we still wish each other the 'compliments of the season'.

Except where otherwise attributed, the excerpts are all taken from *Cider with Rosie*. The accompanying pictures shadow and honour the changing seasons, as true as can be to the poet's mood and thoughts. Referring to *Cider with Rosie*, the first of his three volumes of autobiography, Laurie Lee says, 'I was moved by several needs, but the chief one was celebration.' I can't come up with a better reason for this book.

JAMES BIRDSALL, WHARFEDALE 2001

Right: Down Lane.

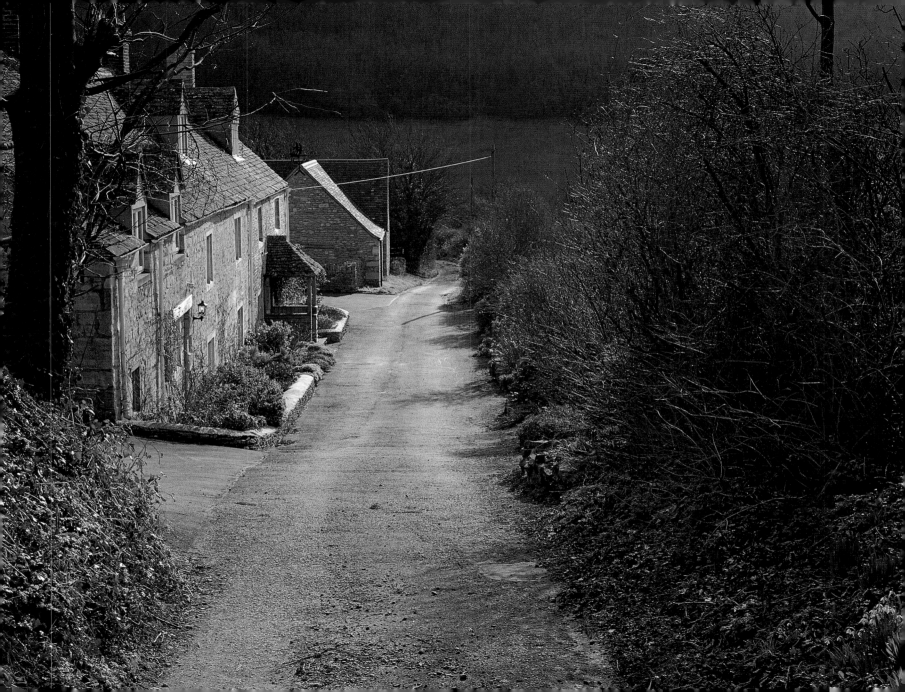

MILESTONES
Laurie Lee: 1914–1997

1914 JUNE: Laurie Lee born in Stroud, Gloucestershire, to Annie (née Light) and Reg Lee. AUGUST: war breaks out in Europe.

1917 The family move to the cottage in the Cotswold village of Slad.

1918 Laurie starts his education at the village school. 11 NOVEMBER: the signing of the Armistice ends World War 1.

1926 To the Central Boys' School at Stroud.

1929 Leaves school.

1930 Starts work as an office boy at a firm of chartered accountants in Stroud.

1933 Has poem, 'Jazz', published locally in the *Gloucester Citizen*.

1934 JUNE: Leaves Slad for London, going on foot via Southampton, busking for pennies with his violin. Later, living in Putney, works as a builder's labourer.

1935 JULY: crosses from Tilbury Docks to Vigo, Spain. Here he walks and plays his violin, eventually reaching the Mediterranean.

1936 JULY: outbreak of Spanish Civil War, during which Spain became an ideological battleground for fascists and socialists from all countries. AUGUST: Laurie is evacuated by the Royal Navy on HMS *Blanche*.

1937 DECEMBER: returns to Spain to join the International Brigade to fight on the Republican (socialist) side in the civil war (1936-9) against the Fascists.

1938 FEBRUARY: returns from Spain. Recruited by brother Jack for a GPO (General Post Office) propaganda film unit anticipating war.

1939 MARCH: Laurie's daughter Yasmin is born to Lorna Wishart, his mistress and muse for the past two years. Spanish Civil War ends in victory for General Franco's Nationalists over the Republican government. SEPTEMBER: Britain declares war on Germany.

1942 Joins the Crown Film Unit as a script writer for wartime documentaries from the 'home front'.

1944 *The Sun My Monument* (poems) is published.

1945 MAY: victory for the Allied Forces in Europe. AUGUST: Japan surrenders.

1947 *The Bloom of Candles* (poems) is published.

1948 *The Voyage of Magellan*, a verse play for the wireless, is broadcast.

1950 Joins the Festival of Britain team as chief caption writer. MAY: marries Katherine (Kathy) Polge. AUGUST: Laurie's mother dies at Slad aged 71.

1951 The Festival of Britain opens on the South Bank of the Thames in London.

1955 *My Many Coated Man*, a collection of poems, and *A Rose for Winter*, an account of travels in Andalusia (Spain), are published.

1959 *Cider with Rosie*, a record of Lee's rural boyhood, and first of three autobiographies, is published to wide acclaim.

1960 *Pocket Poems* is published, part of a series of 'Pocket Poets', including Rupert Brooke and Edward Thomas. Laurie dedicated it 'To Y'.

1961 The Lees buy the seventeenth-century Rose Cottage in Slad.

1962 Laurie performs regularly at poetry and jazz evenings countrywide along with others such as Danny Abse, Ted Hughes, Stevie Smith and Spike Milligan.

1963 Laurie meets Lorna Wishart again after more than twelve years, independently visiting their daughter Yasmin, who is expecting her first baby. SEPTEMBER: a daughter, Jessy, is born to Kathy and Laurie a few hours after Yasmin's daughter is born. Thus he becomes father and grandfather on the same day.

1964 *The Firstborn* is published (originally in the *London Evening Standard*).

1969 *As I Walked Out One Midsummer Morning*, sequel to *Cider with Rosie*, is published, being an account of his journey away from Slad, life in London and his first travels in Spain.

1972 Laurie buys the Sheepscombe village cricket ground to preserve it from developers.

1975 *I Can't Stay Long*, a collection of occasional writing, is published.

1983 *Two Women*, a tribute to Kathy and Jessy, is published.

1991 *A Moment of War* (the Spanish War), the last of the autobiographical trilogy, is published.

1997 Laurie Lee dies in May and is buried in Slad churchyard.

2000 JANUARY: Lorna Wishart dies aged 89.

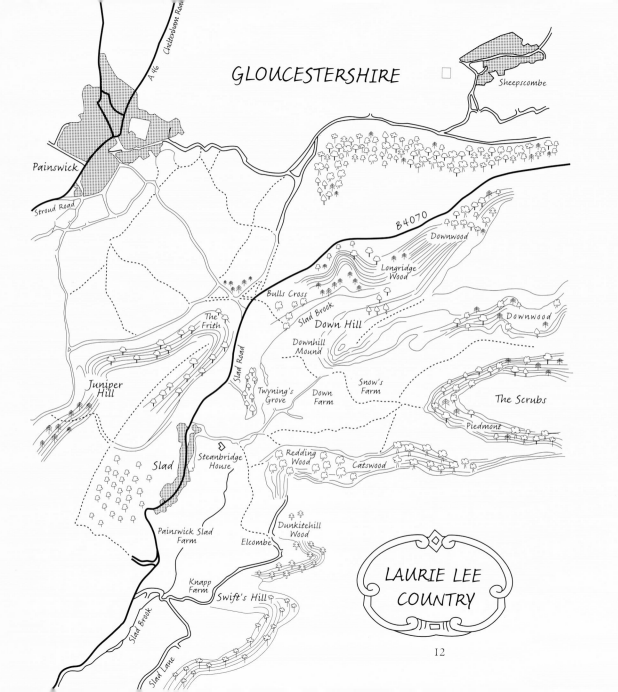

GLOUCESTERSHIRE

THE SLAD VALLEY

Sheepscombe

Painswick

Stroud Road

A 46
Cheltenham Road

B4070

Downwood

Longridge
Wood

Bulls Cross

Slad Brook

Down Hill

Downwood

The
Frith

Downhill
Mound

Snow's
Farm

The Scrubs

Juniper
Hill

Slad Road

Twyning's
Grove

Down
Farm

Piedmont

Slad

Steanbridge
House

Redding
Wood

Catswood

Painswick Slad
Farm

Dunkitehill
Wood

Elcombe

LAURIE LEE
COUNTRY

Knapp
Farm

Swift's Hill

Slad Brook

Slad Lane

LEE FAMILY TREE

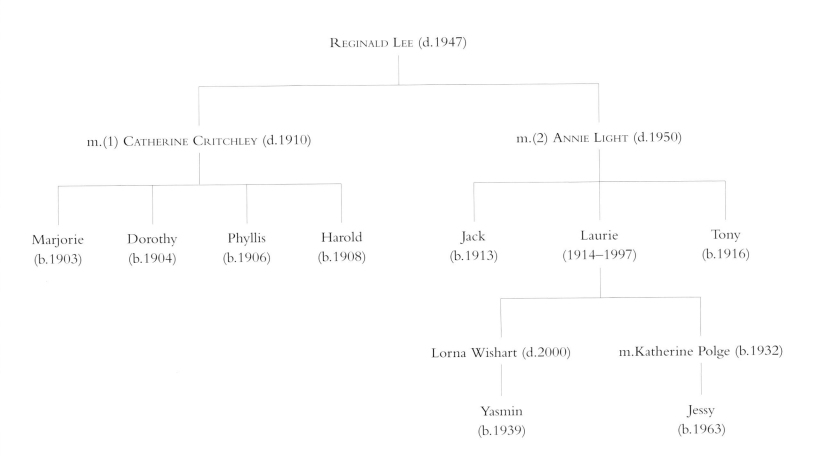

REGINALD LEE (d.1947)

m.(1) CATHERINE CRITCHLEY (d.1910) m.(2) ANNIE LIGHT (d.1950)

Marjorie Dorothy Phyllis Harold Jack Laurie Tony
(b.1903) (b.1904) (b.1906) (b.1908) (b.1913) (1914–1997) (b.1916)

Lorna Wishart (d.2000) m.Katherine Polge (b.1932)

Yasmin Jessy
(b.1939) (b.1963)

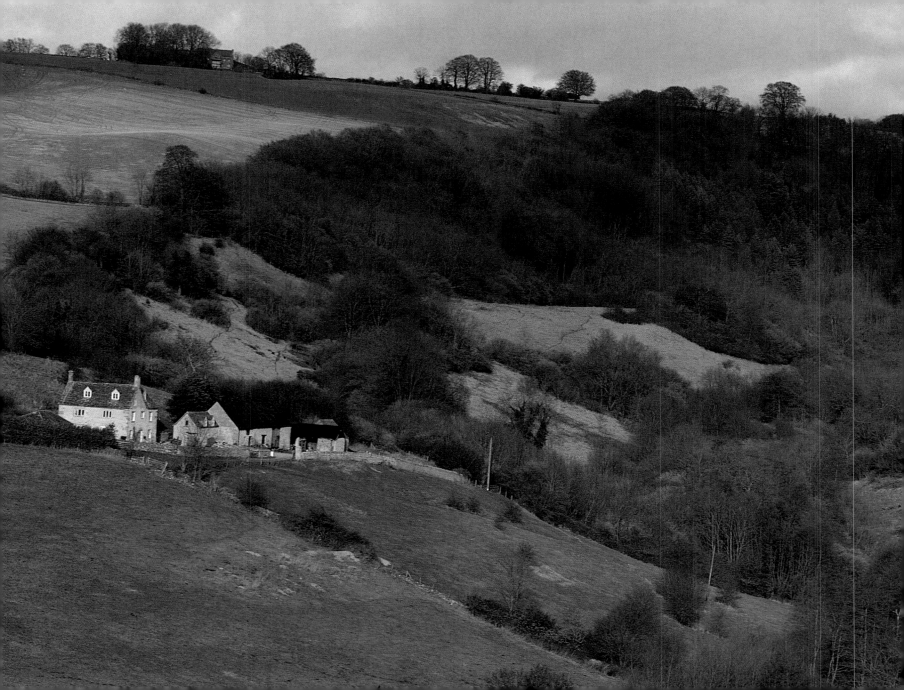

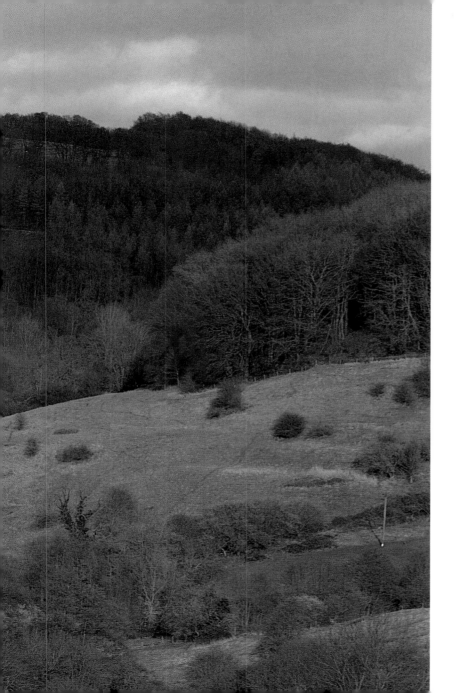

PROLOGUE

In 1951 Laurie Lee was a member of the organising committee of the Festival of Britain. These, his five lyric couplets, printed on a set of plates, were on display in the central Dome of Discovery on the South Bank of the Thames.

Four seasons square the rounded year,
And all in Nature's glass appear.

Left: *View of Downwood from Catswood.*

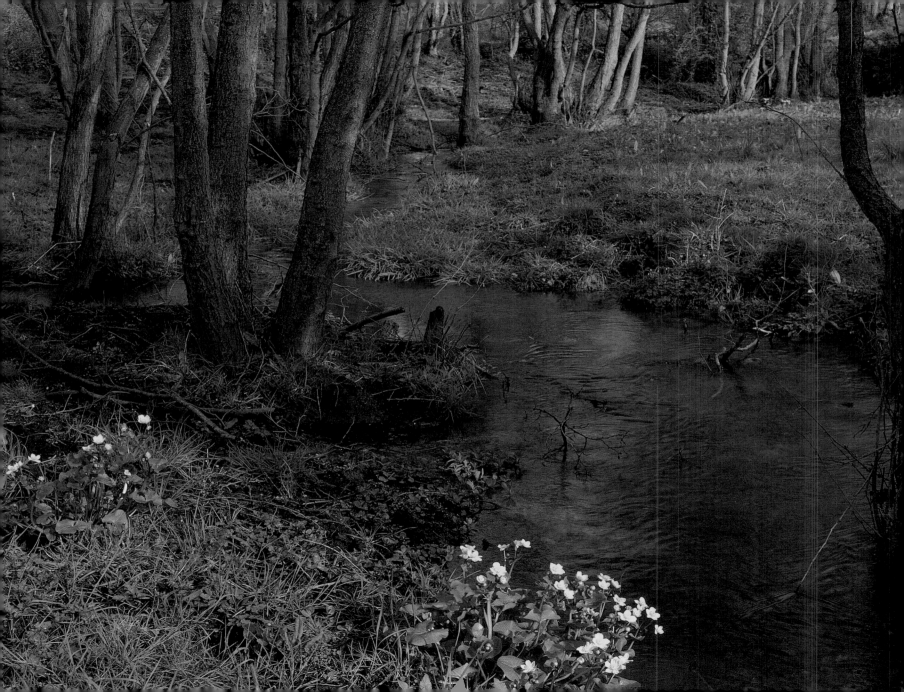

With leaf-green eyes, and lips half curled,
Spring lends a white lamb through the world.

Butter the hedgerow with cream-fat roses:
Gorged with his garlands, the Summer dozes.

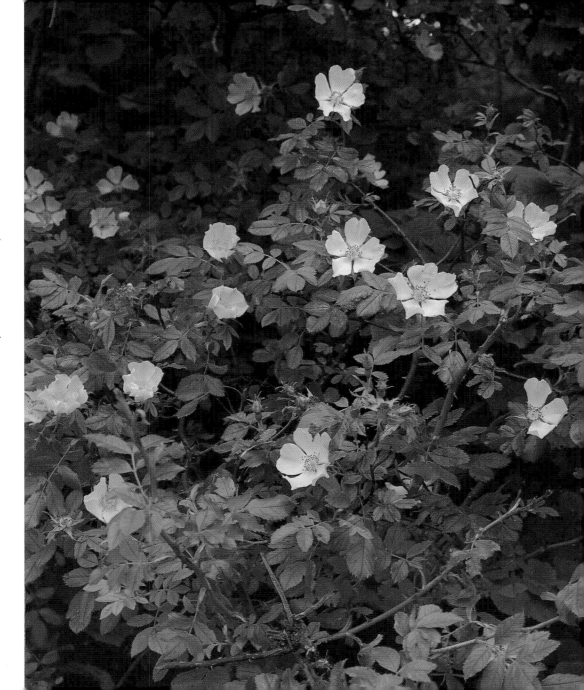

Left: *Slad Brook.*
Right: *Wild dog roses.*

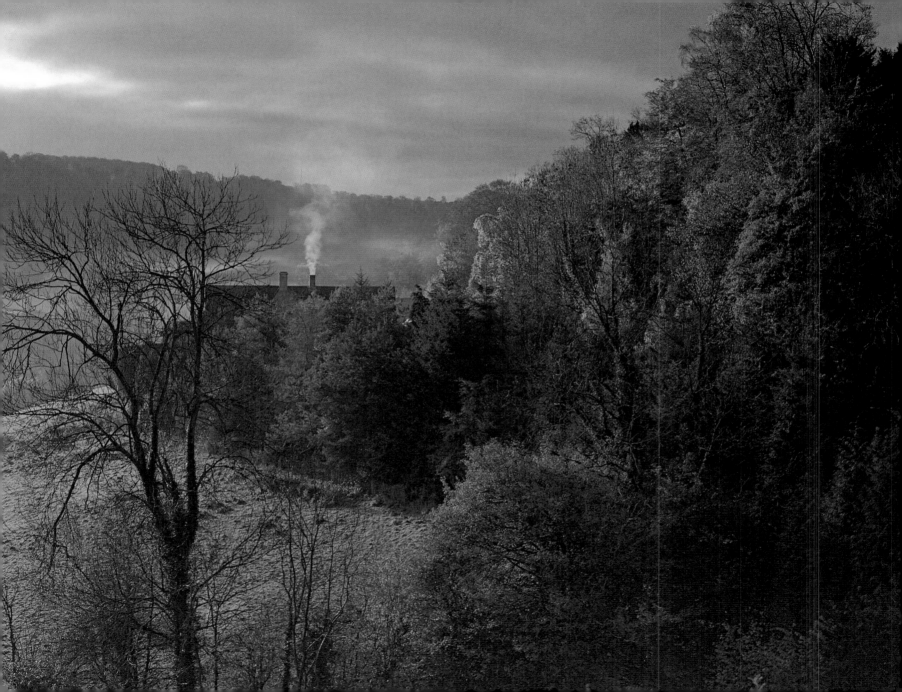

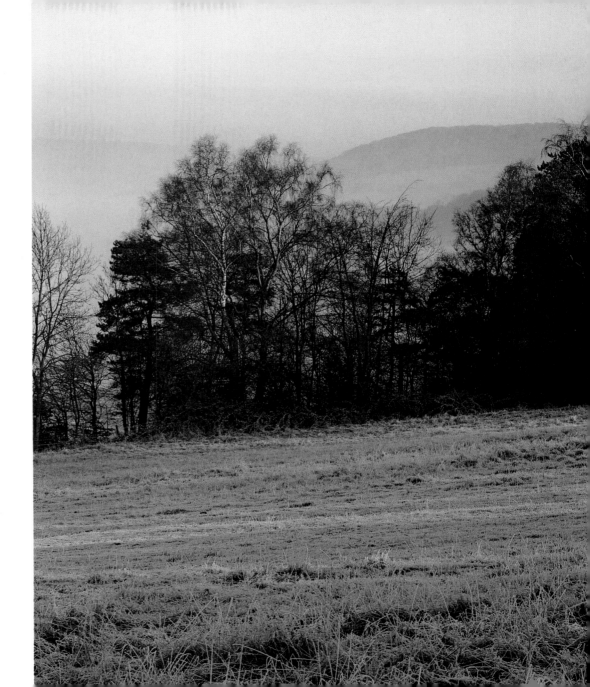

Ancestral Autumn, with hands of brass,
Shakes the last apple on the grass.

The Wintry crow creaks home to hide
And frost locks up the countryside.

Left: Painswick Slad Farm.
Right: View from Firth Wood towards
Sheepscombe.

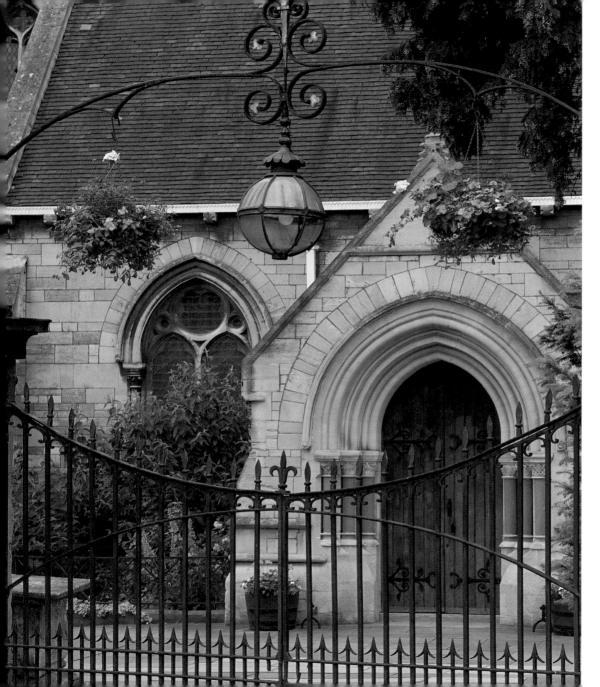

LAURIE LEE COUNTRY

Laurie Lee was born in June 1914, in Stroud, Gloucestershire, just a few weeks before Europe erupted in a cataclysmic world war. He was christened at St Laurence's Church, Stroud, after which saint he was given his name. He arrived at the cottage in the Cotswold village of Slad, with his mother, brothers and half-sisters, just three years later in the June of 1917.

The village to which our family had come was a scattering of some twenty to thirty houses down the south-east slope of a valley.

Left: St Lawrence's Church, Stroud.
Right: View of Slad Valley from Swift's Hill.

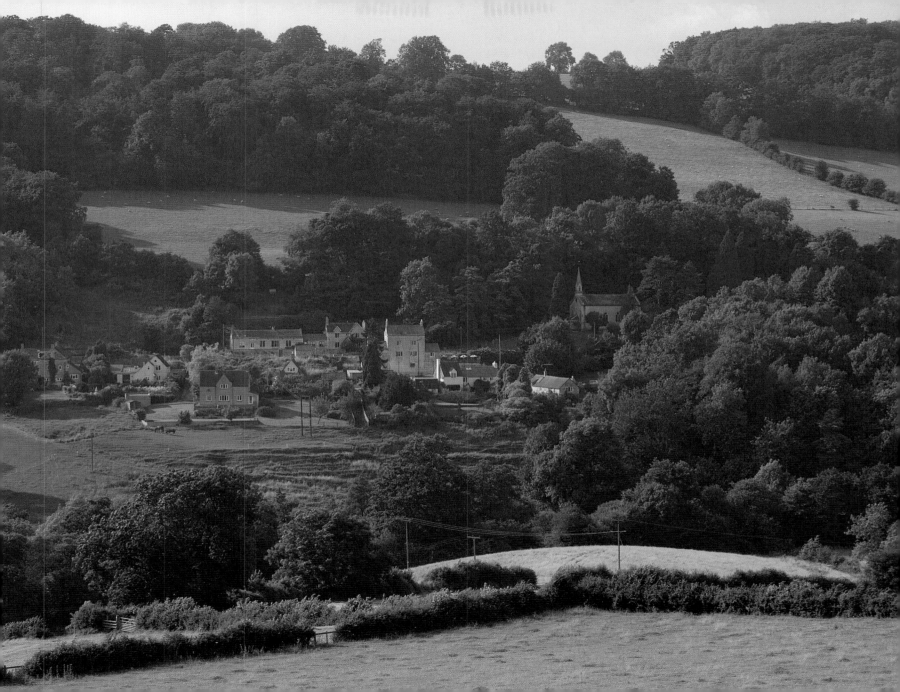

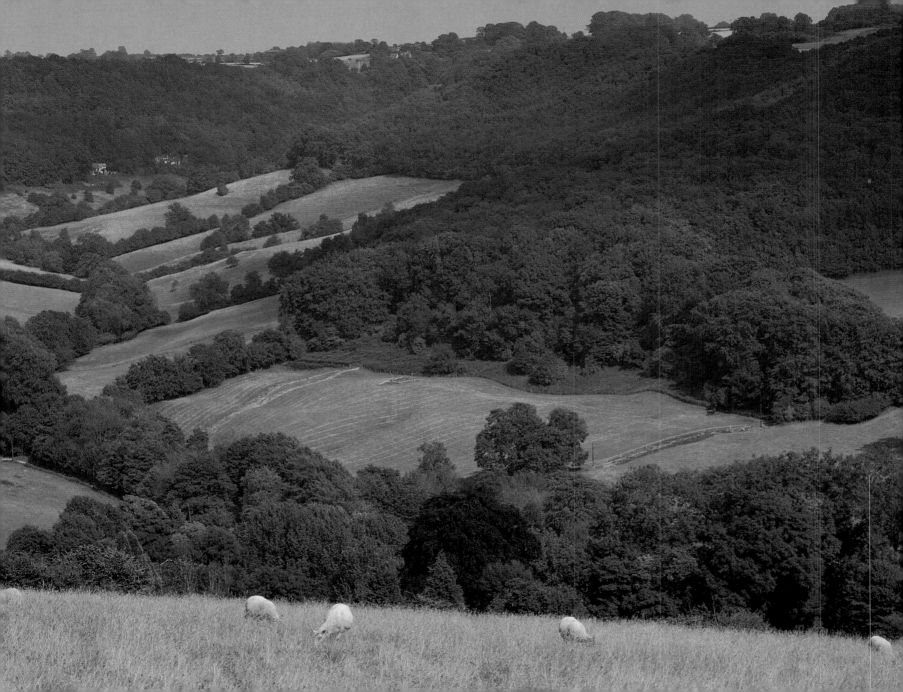

The valley was narrow, steep, and almost entirely cut off; it was also a funnel for winds, a channel for the floods and a jungly, bird-crammed, insect-hopping sun trap whenever there happened to be any sun.

. . .

It was not high and open ... but had secret origins, having been gouged from the Escarpment by the melting ice-caps some time before we got there. The old flood-terraces still showed on the slopes, along which the cows walked sideways.

Left: View of Slad Valley from Juniper Hill.
Right: View of The Scrubs and Catswood.

It was something we just had time to inherit, to inherit and dimly know – the blood and beliefs of generations who had been in this valley since the Stone Age. That continuous contact has now been broken. But arriving, as I did, at the end of that age, I caught whiffs of something old as the glaciers. There were ghosts in the stones, in the trees, and the walls, and each field and hill had several. The elder people knew about these things and would refer to them in personal terms, and there were certain landmarks about the valley – tree-clumps, corners in woods – that bore separate, antique, half-muttered names that were certainly older than Christian.

Right: Downhill Mound.

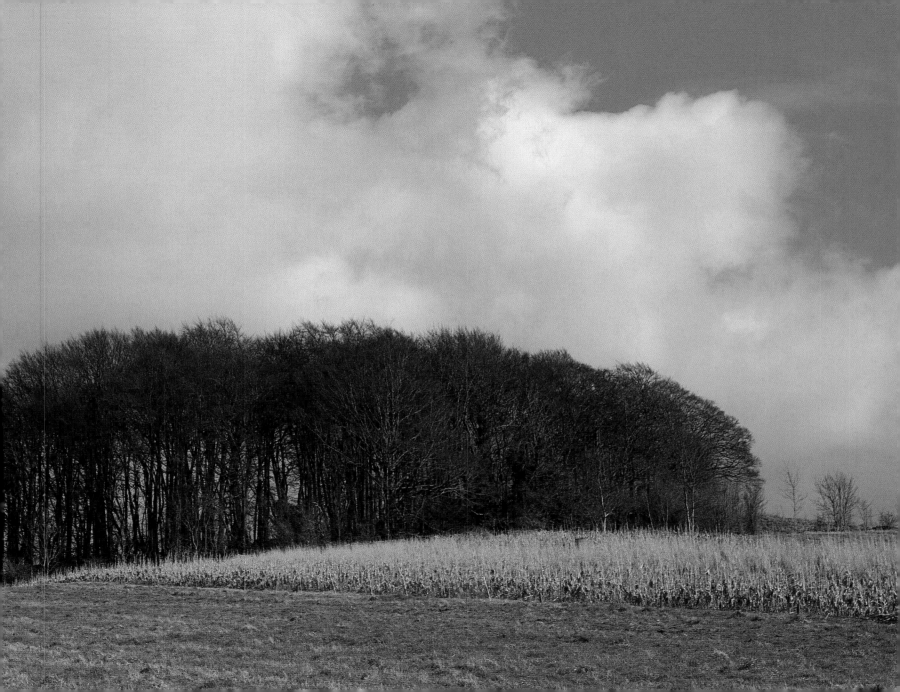

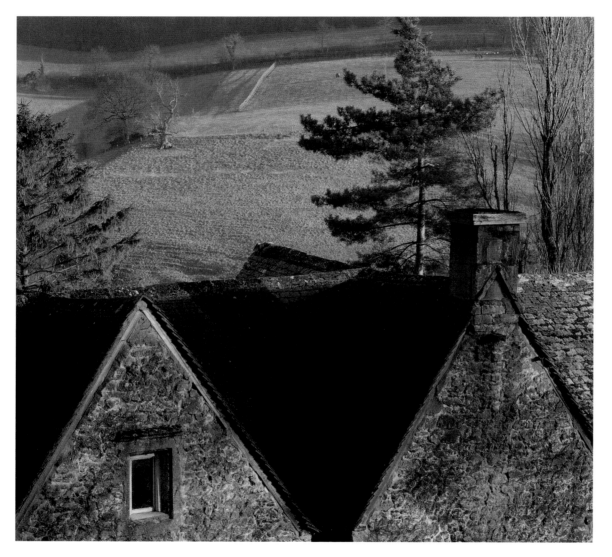

Most of the cottages were built of Cotswold stone and were roofed by split-stone tiles. The tiles grew a kind of golden moss which sparkled like crystallized honey.

Left and Right: Wade's Farm.

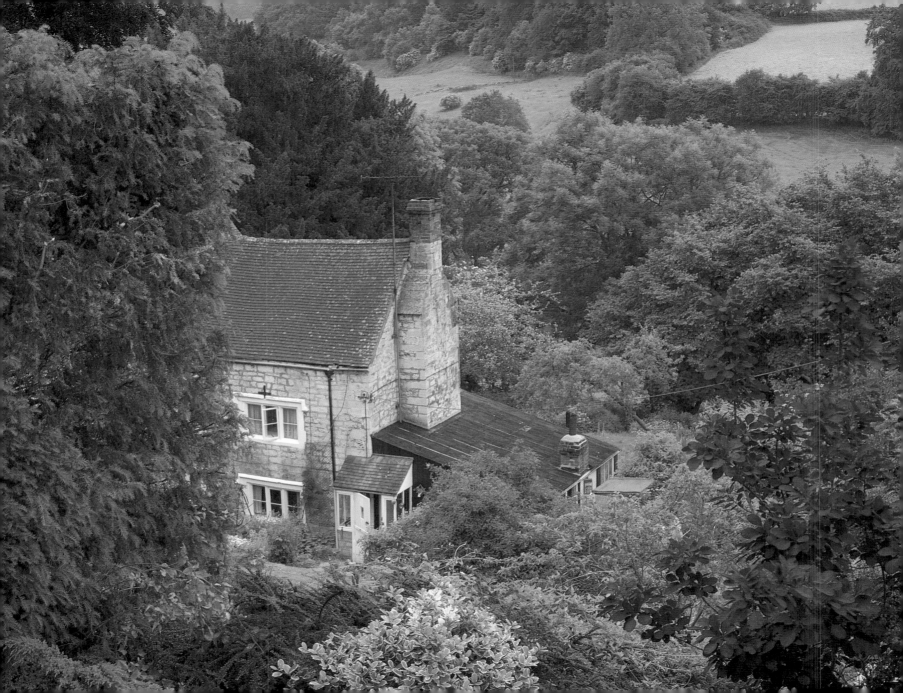

I was set down from the carrier's cart at the age of three; and there with a sense of bewilderment and terror my life in the village began ... To a cottage that stood in a half-acre of garden on a steep bank above a lake; a cottage with three floors and a cellar and a treasure in the walls, with a pump and apple trees, syringa and strawberries, rooks in the chimneys, frogs in the cellar, mushrooms on the ceiling, and all for three and sixpence a week.

. . .

Our house was seventeenth-century Cotswold and handsome as they go. It was built of stone, had hand-carved windows, golden surfaces, moss-flaked tiles, and walls so thick they kept a damp chill inside them whatever the season or weather.

Left: Rose Bank, where Lee lived as a boy.
Right: Garden at Rose Bank.

First the cottage, then the tousled garden, and by degrees the valley itself became the known world to the young Laurie.

First of course comes England, the home country, the limit of what is familiar. The entire realm lies immediately outside the house and stretches no further than the village edge. It consists of a few wild flowers, a mass of jungly grass, an ant-hill, an oak tree, a bees' nest, and a flakestone quarry clustered with Roman snails.

Eight Year-Old World

. . .

This detailed landscape is all I know of England. It is home, the country we sing at school; and every event of history can be sited somewhere among its fields. King Charles once hid in that oak tree ...

Eight Year-Old World

Right: *Slad Lane.*

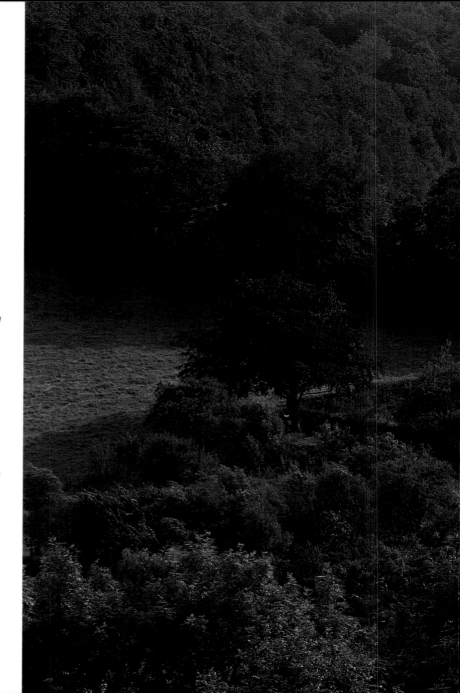

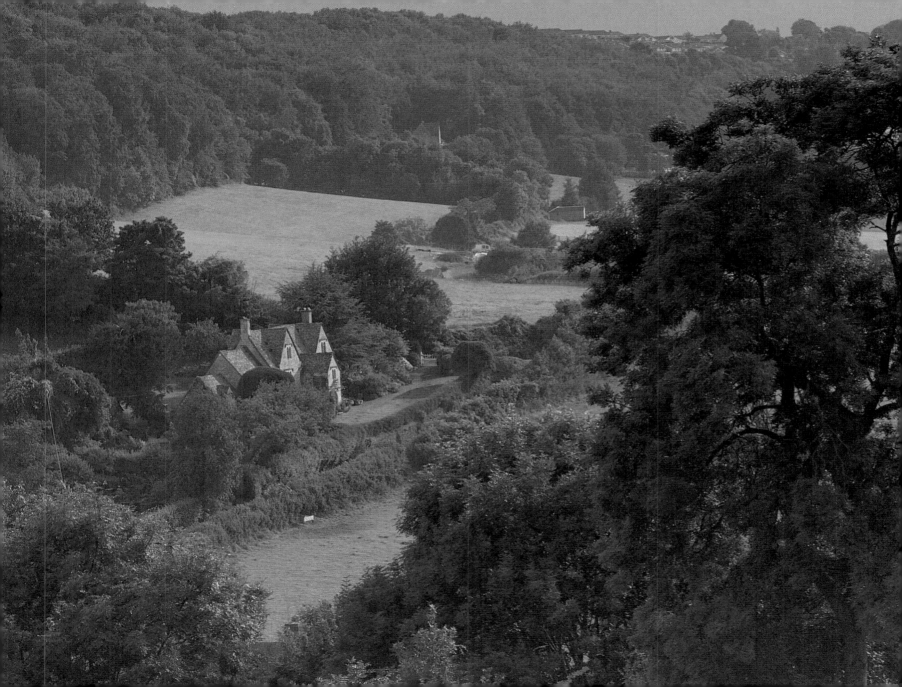

... King Rufus was murdered in that dusty wood, all battles were fought on that brambled bank, and every Queen was born here.

Eight Year-Old World

. . .

England, beyond the boundaries of the familiar parish is unimaginable. Beyond all these we come to the edge of the world, and the grass-grown cliffs drop sheer into the dark ... The world is behind me. The garden path leads outward to the moon, and I have no idea when I'll be back.

Eight Year-Old World

Left: *Frosty brambles, The Scrubs.*
Right: *Down Farm from Redding Wood.*

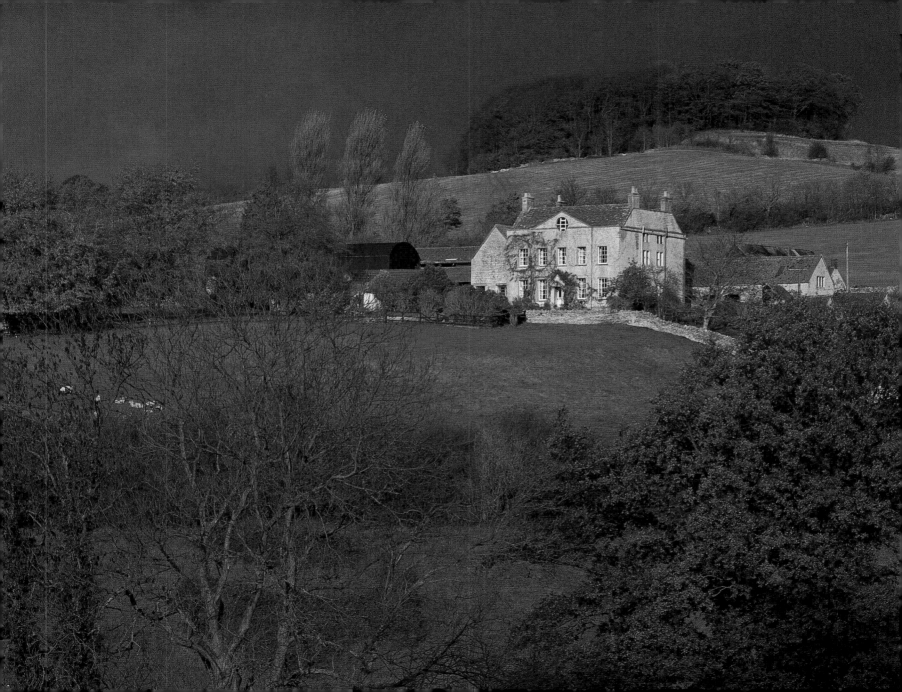

As time passed and young legs grew sturdier, the confines widened and more prosaic landmarks asserted themselves. School, after a wildly traumatic wrench from the comfort of a benign feminine rule at home, gained the ascendancy. Friends were made, enemies warily circumvented and village lore and custom osmotically absorbed. But the trailing clouds of glory were never to be entirely shaken free; the child in Laurie discernibly continued to exist throughout the poet's long life.

In the very sump of the valley wallowed the Squire's Big House – once a fine though modest sixteenth-century manor, to which a Georgian façade had been added.

Left: *Steanbridge House, Slad, home of the Squire.*

Miss Flynn lived up on the other side of the valley in a cottage which faced the Severn, a cottage whose rows of tinted windows all burst into flame at sundown.

. . .

A fold in the limestone hills where the summer vegetation grows with all the matted fierceness of the Burmese jungle ... Little evidence of life up there, save for one broken, tile-spilling farm ... and half a mile away – at the farthest fold of the valley – the tiny chapel, buried in its jungle.

A Drink with a Witch

Left: *Woodside Cottage, Elcombe, home of Miss Flynn.*
Right: *The Slad Valley from Swift's Hill.*

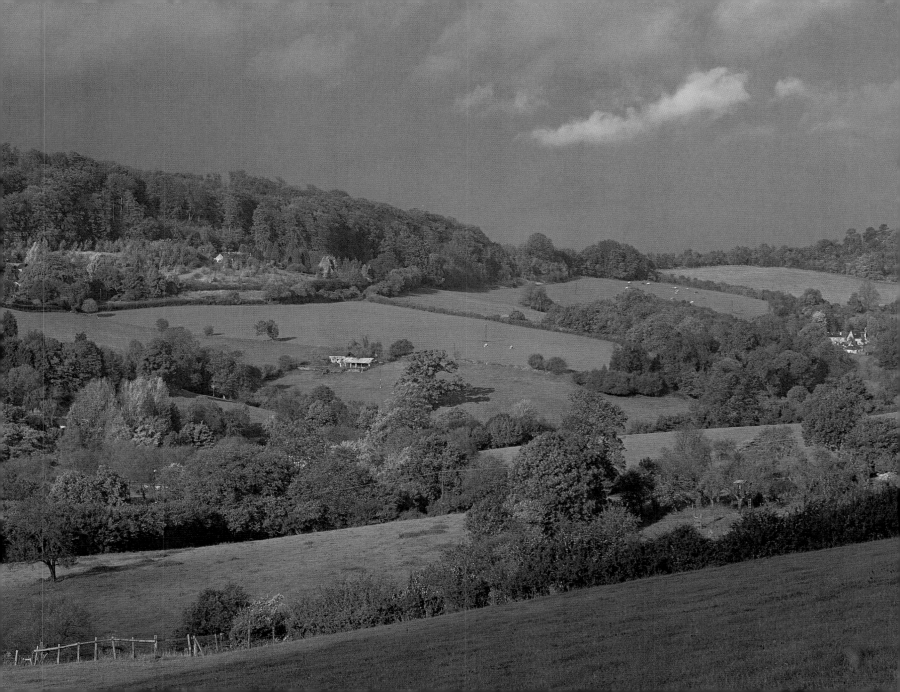

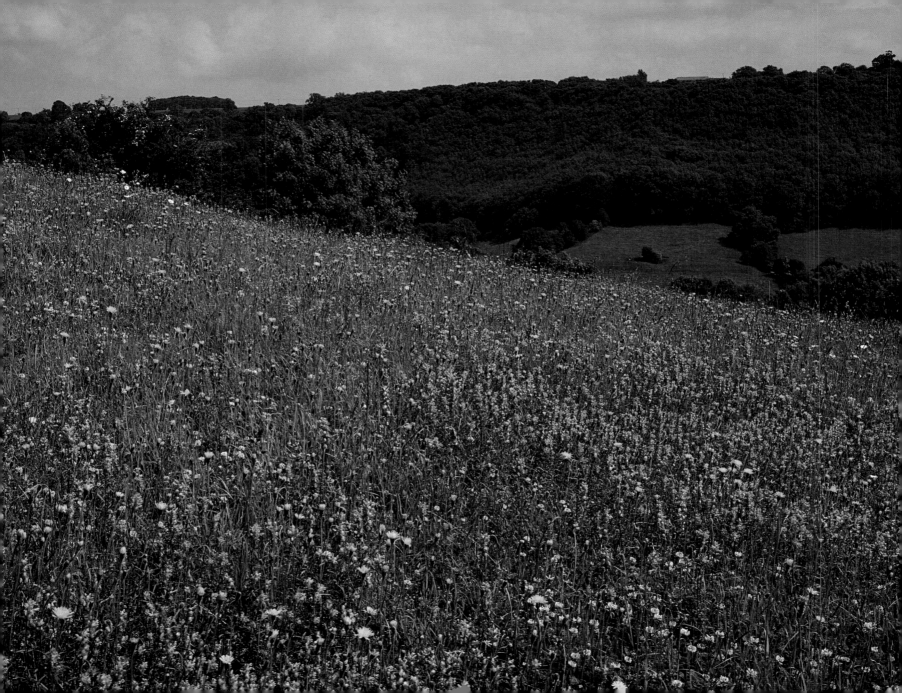

The village in fact was like a deep running cave still linked to its ancient past, a cave whose shutters were cluttered by spirits and by laws still vaguely ancestral.

· · ·

This cave ... had not as yet been tidied up, or scrubbed clean by electric light, or suburbanized by a Victorian church, or papered by cinema screens.

Above: Old School, Slad, which Lee attended.
Left: Meadow at Down Farm.

The village school at that time provided all the instruction we were likely to ask for ... Every child in the valley crowding there, remained till he was fourteen years old, then was presented to the working field or factory with nothing in his head more burdensome than a few mnemonics, a jumbled list of wars, and a dreamy image of the world's geography. It seemed enough to get by with, in any case; and was one up on our poor old grandparents ...

Wild boys and girls from miles around – from the outlying farms and half-hidden hovels way up at the ends of the valley – swept down each day to add to our numbers, bringing with them strange oaths and odours, quaint garments and curious pies.

Samuel Gilbert Jones was the paternal squire, whose house (originally Jacobean), garden and woods were a traditional hub for the cycle of village activity. His ponds were on hand for fishing and skating in season, his gardens opened for fêtes and rural junketing, and the old gentleman himself was always the first and most profitable call when the choirboys went carol singing.

This huge stone house with its ivied walls was always a mystery to us. As we sang 'Wild Shepherds' we craned our necks, gaping into that lamplit hall which we had never entered; staring at the muskets and untenanted chairs, the great tapestries furred by dust – until suddenly, on the stairs, we saw the old squire himself standing and listening with his head on one side. He didn't move until we'd finished; then slowly he tottered towards us, dropped two coins in our box with a trembling hand, scratched his name in the book we carried, gave us each a long look with his moist blind eyes, then turned away in silence.

'Two shillings.' This was quite a good start. No one of any worth in the district would dare to give us less than the Squire.

Left: Steanbridge Mill, Slad.
Right: Pond in Longridge Wood.

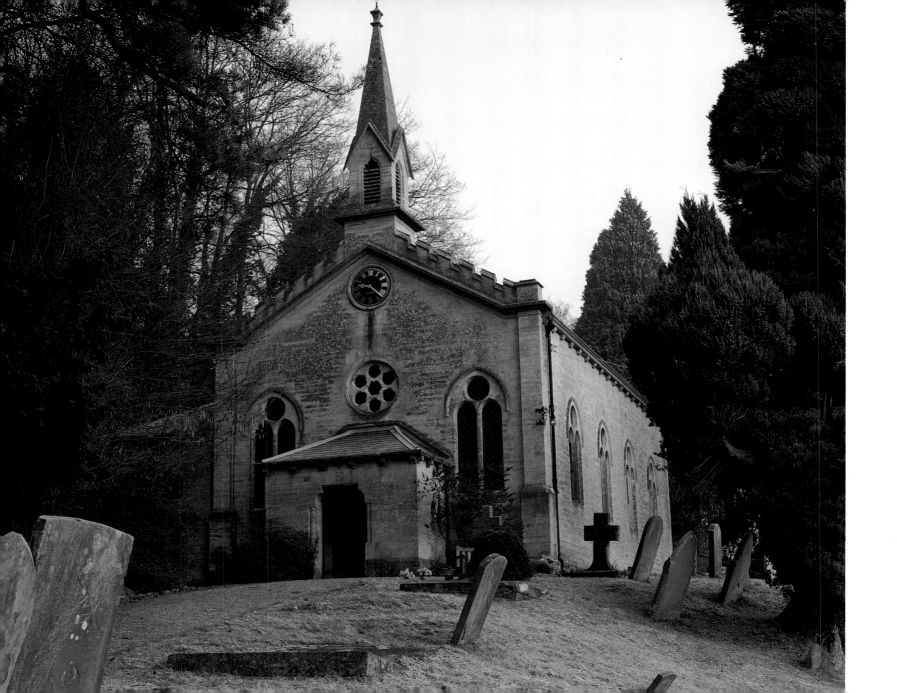

For the choir in particular, Sundays were in many ways more regimented than schooldays; baths the night before, struggling into Sunday Best, two services to attend and the Collect to learn by heart.

After an hour of Sunday School we all went to the church, the choir going straight to the vestry. Here we huddled ourselves into our grimy robes, which only got washed at Easter. The parson lined us up and gave us a short, sharp prayer; then we filed into the stalls, took our privileged places, and studied the congregation.

. . .

All were neatly arranged by protocol, with the Squire up front by the pulpit. Through prayers and psalms and rackety hymns he slept like a beaming child, save when a visiting preacher took some rhetorical flight, when he'd wake with a loud 'God damn!'

. . .

Morning service began with an organ voluntary, perhaps a Strauss waltz played very slow. The organ was old, and its creaks and sighs were often louder than the music itself. The organ was blown by an ordinary pump-handle which made the process equally rowdy; and Rex Brown, the blower, hidden away in his box – and only visible to us in the choir – enlivened the service by parodying it in mime or by carving girls' names on the woodwork.

Left: Holy Trinity Church, Slad, where Lee is buried.
Right: Interior of Holy Trinity Church, Slad.

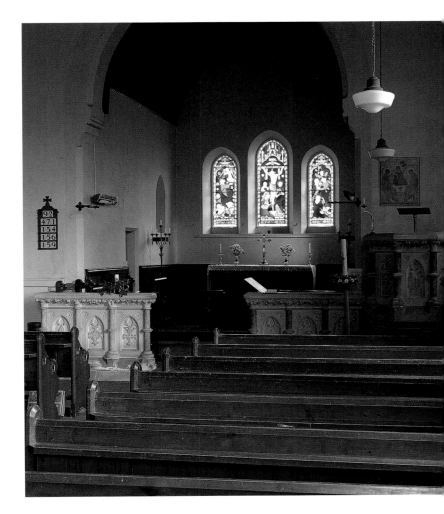

Later came Evensong, which was as different from Matins as a tryst from a Trafalgar Square rally. The church at night was just a strip of red-fired windows. Inside the oil-lamps and motionless candles narrowed the place with shadows. 'Lord, now lettest thou thy servant depart in peace ...' It was sung, eyes closed, in trembling tones. It could not have been sung in the morning.

· · ·

From our seats in the choir we watched the year turn: Christmas, Easter and Whitsun, Rogation Sunday and prayers for rain, the Church following the plough very close. Harvest Festival perhaps was the one we liked best, the one that came nearest home. Then how heavily and abundantly was our small church loaded; the cream of the valley was used to decorate it. Square-rumped farmers and ploughmen in chokers, old gardeners and poultry-keepers, they nodded and pointed and prodded each other to draw attention to what they had brought. And even where we sang, 'All is safely gathered in', knowing full well that some of Farmer Lusty's oats still lay rotting in the fields, the discrepancy didn't seem important.

Left: St Mary's Church, Painswick, at dusk.
Right: Churchyard, Holy Trinity Church, Slad.

From harvest home through winter snows, to seed-time awakening and summer ease, the seasonal icons, inherent and inbred, furnish much of the imagery which inspires Laurie Lee's poetry. Love and lust, war and death are reflected in the ever bright mirror of the forsaken valleys of his boyhood.

Right: *View of Sheepscombe.*

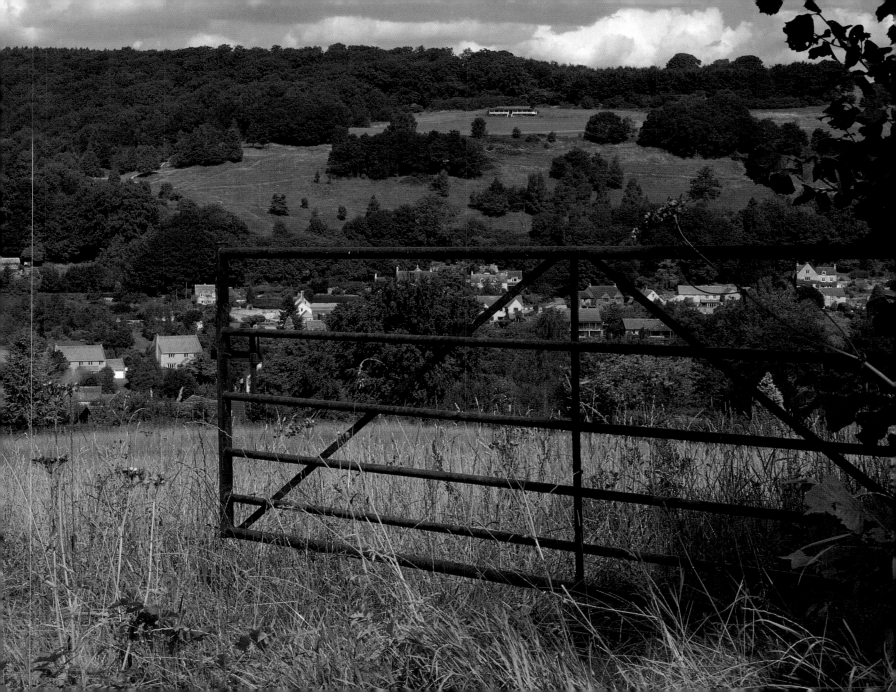

Yet though by sullen violence we are torn
from violet couches as the air grows sweet,
and by the brutal bugles of retreat
recalled to snows of death, yet Spring, repeat
your annual attack, pour through the breach
of some new heart your future victories.

The Armoured Valley

. . .

The snowdrops make a sharp white sound,
percussions of frost on the crow black earth,
or bells for children in their steeple fingers
rung for the eyes to echo like a church.

Time of Anxiety

Left: *Painswick.*
Right: *Trillgate Cottage.*

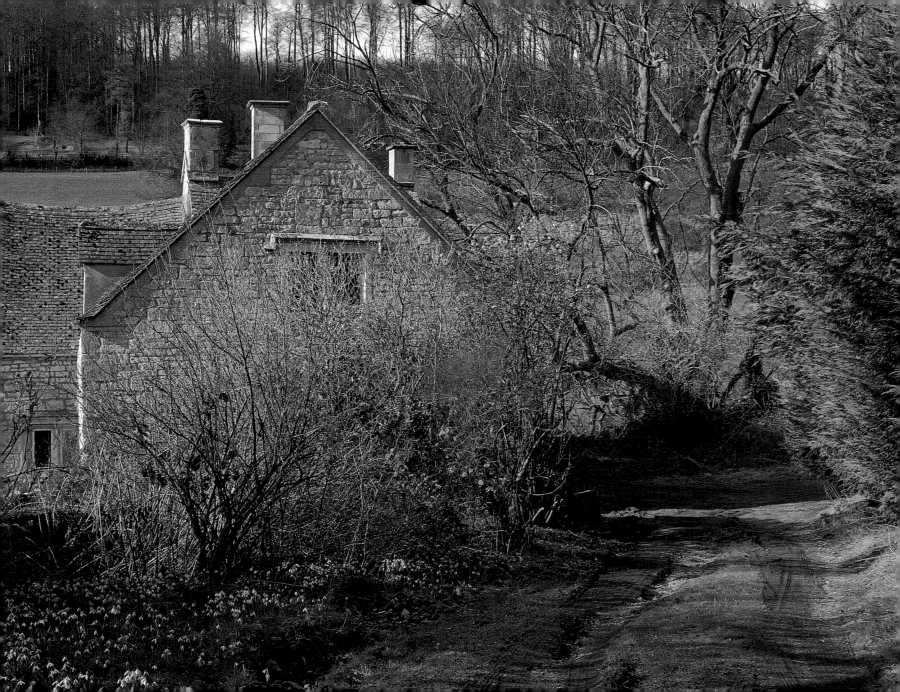

And she walked in fields where the crocuses
branded her feet, and mares' tails sprang
from the prancing lake, and the salty grasses
surged round her stranded body.

First Love

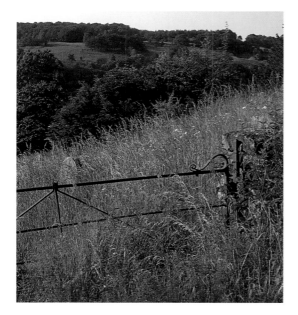

Above: *Gate to Churchyard, Sheepscombe.*
Right: *Longridge Wood.*

If ever I saw blessing in the air
 I see it now in this still early day
Where lemon-green the vaporous morning drips
 Wet sunlight on the powder of my eye

Blown bubble-film of blue, the sky wraps round
 Weeds of warm light whose every root and rod
Splutters with soapy green, and all the world
 Sweats with the bead of summer in its bud.

If ever I heard blessing it is there
 Where birds in trees that shoals and shadows are
Splash with their hidden wings and drops of sound
 Break on my ears their crests of throbbing air.

Pure in the haze the emerald sun dilates,
 The lips of sparrows milk the mossy stones,
While white as water by the lake a girl
 Swims her green hand among the gathered swans.

Now, as the almond burns its smoking wick,
 Dropping small flames to light the candled grass;
Now, as my low blood scales its second chance,
 If ever world were blessed, now it is.

April Rise

51

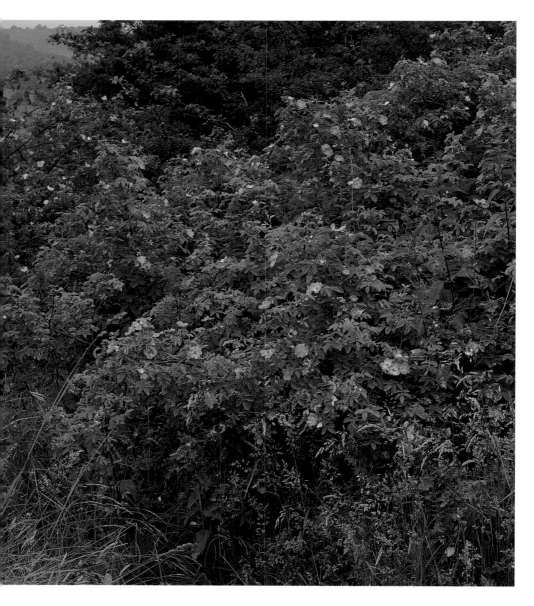

Cold in their hope our mortal eyes forgather,
wandering like moths about the tomb's shut mouth;
Waiting the word the riven rock shall utter,
waiting the dawn to fly its bird of god.

Poem for Easter

. . .

Tired of this northern tune
the winds turn soft
Blowing white butterflies
out of the dog-rose hedges ...

The Three Winds

Left: *Wild dog roses*
Right: *Knapp Farm.*

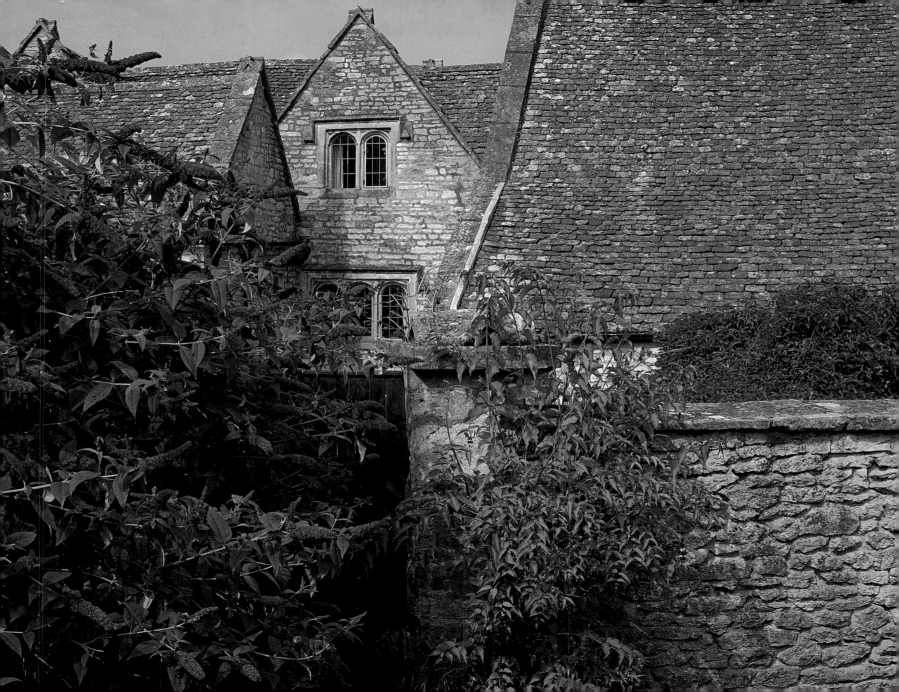

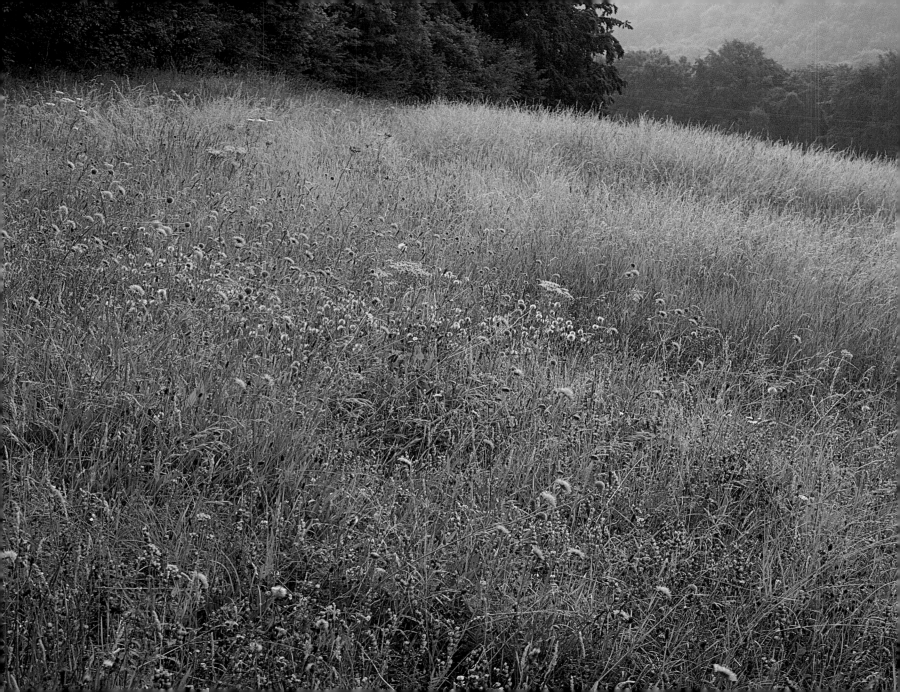

This world, this comfortable meadow,
gay with surprise and treasure ...

Look Into Wombs

. . .

The yew trees,
wearing the afternoon like a copper helmet.

The Return

Left: *Grass meadow at Bulls Cross.*
Right: *St Mary's Church, Painswick.*

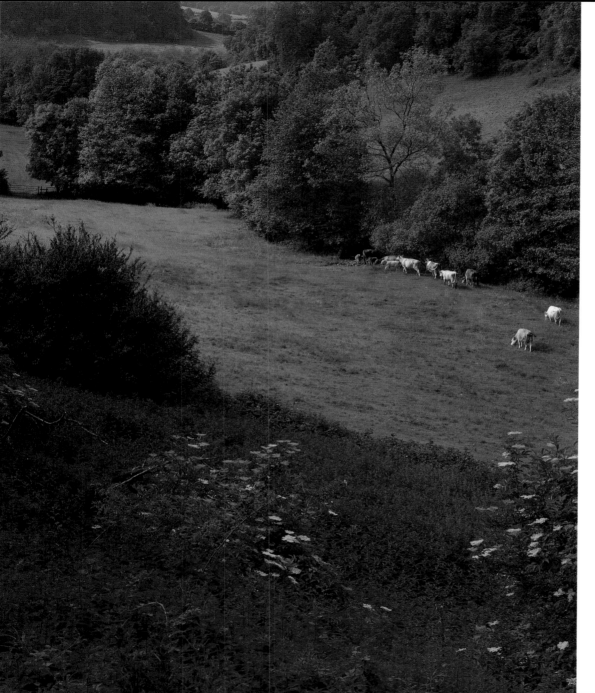

The morning is white
with the hot frost of elder,
blizzards of scent
blind the shuddering walls.

River

. . .

O where is the river
and where are the willows,
your kisses of hazel
to sweeten my mouth?

River

Left: Cows in pasture at Twyning's Grove.
Right: Longridge Wood.

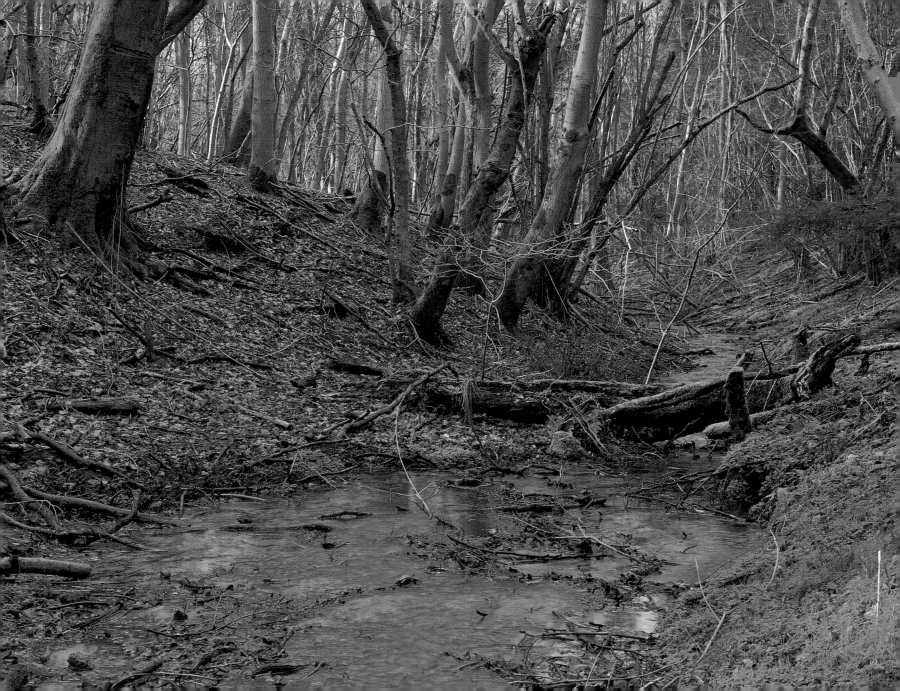

O bring me your river,
your moss-green bridges,
the bank of your breasts
with their hill-cold springs.

River

. . .

I hear the sad rinsing of reeded meadows
The small lakes rise in the wild white rose

Summer Rain

. . .

The heron flies up from the stinging waters,
The white swan droops by the dripping reed,
And summer lies swathed in its ripeness, exuding
Damp odours of lilies and alabaster.

Summer Rain

Left: *Wild roses.*
Right: *Pond in Longridge Wood.*

... the lake explodes silently
with a barrage of lilies.

Poem in the Country

. . .

I see the crazy bees drop fat
From tulips ten times gorged and dry;
I see the sated swallow plunge
To drink the dazzled waterfly.

A halo flares around my head,
A sunflower flares across the sun,
While down the summer's seamless haze
Such feasts of milk and honey run

That lying with my orchid love,
Whose kiss no frost of age can sever,
I cannot doubt the cold is dead,
The gold earth turned to good – forever.

Long Summer

Left: Stroud Canal.
Right: Stroud Canal.

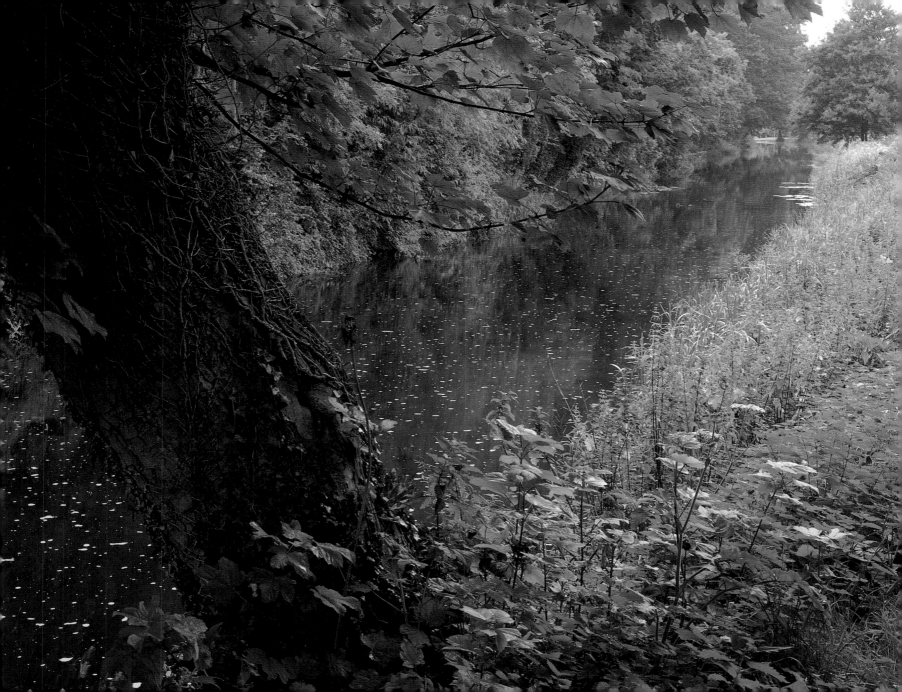

Till August sends at last
its brick-red breath
over the baking wheat and blistered poppy,
brushing with feathered hands
the skies of brass …

The Three Winds

Left: *Painswick*

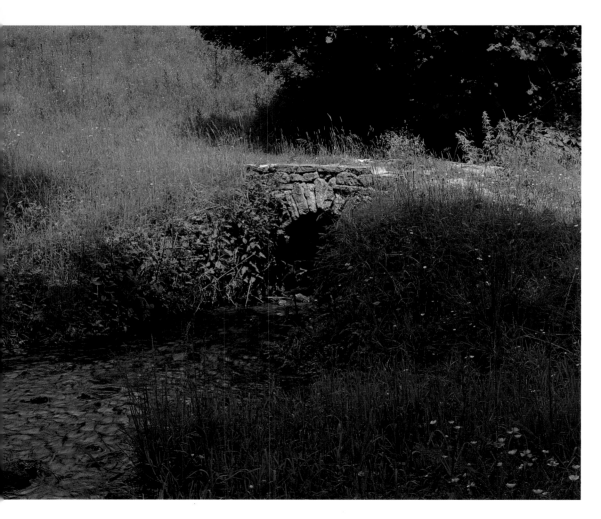

… with dreams of river moss
my thirst's delirium.

The Three Winds

· · ·

Such a morning it is when love
leans through the geranium windows
and calls with a cockerel's tongue.

When hedgerows grow venerable,
berries dry black as blood,
and holes suck in their bees.

Such a morning it is when mice
run whispering from the church,
dragging dropped ears of harvest.

Day of These Days

Left: *Bridge over Slad Brook.*
Right: *Wooded path near Jones's Pond.*

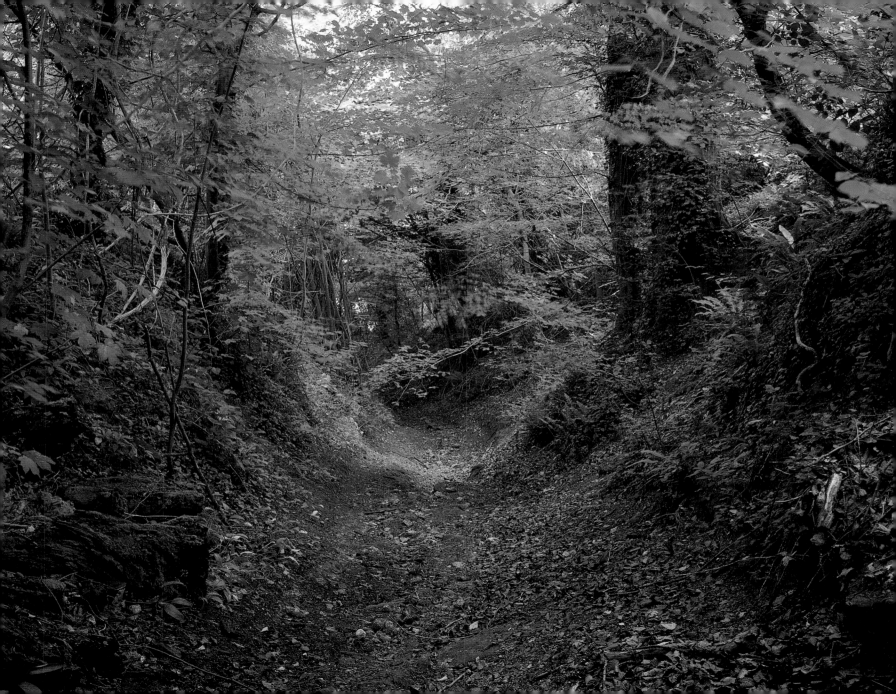

Oh, larch tree with scarlet berries
sharpen the morning slender sun
sharpen the thin taste of September ...

Oh, larch tree with icy hair
Your needles thread the thoughts of snow.

Larch Tree

. . .

Slow moves the acid breath of noon
over the copper coated hill,
slow from the wild crab's bearded breast
the palsied apples fall.

Like coloured smoke the day hangs fire,
taking the village without sound;
the vulture-headed sun lies low
chained to the violet ground.

Field of Autumn

Left: *Swift's Hill.*
Right: *Bulls Cross from Longridge Wood.*

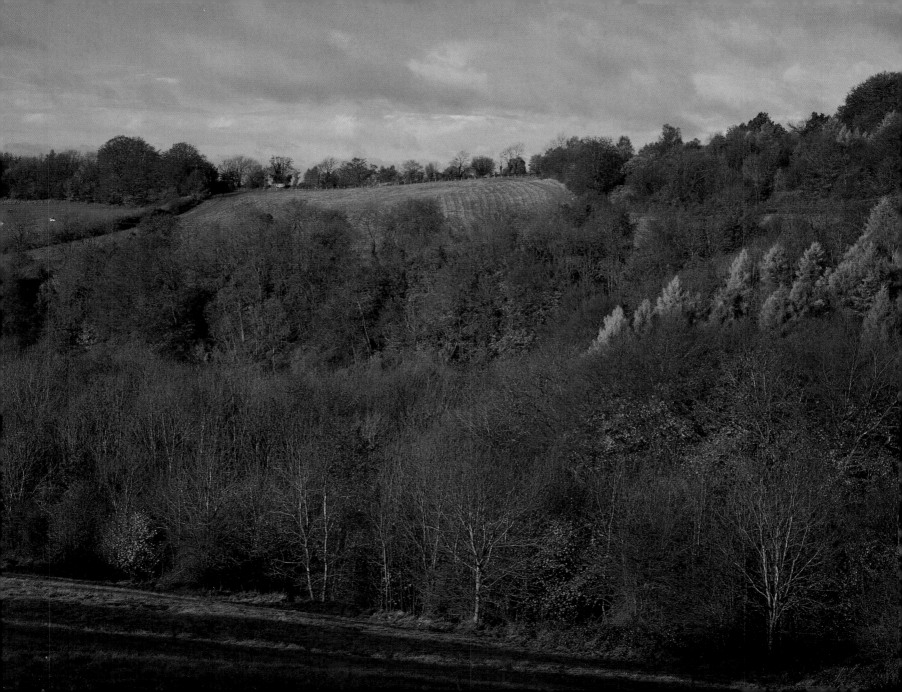

Now tilts the sun his monument,
now sags his raw unwritten stone
deep in October's diamond clay.

And oozy sloes like flies are hung
malignant on the shrivelled stem,
too late to ripen, or to grow.

Equinox

. . .

November loosens the tongue
like a leaf condemned,
and calls through the sharp blue air
a sad dance and a dread of winter.
I hear the branches snap their fingers
and solitary branches crack.

November

Left: *The Scrubs.*
Right: *Twyning's Grove.*

68

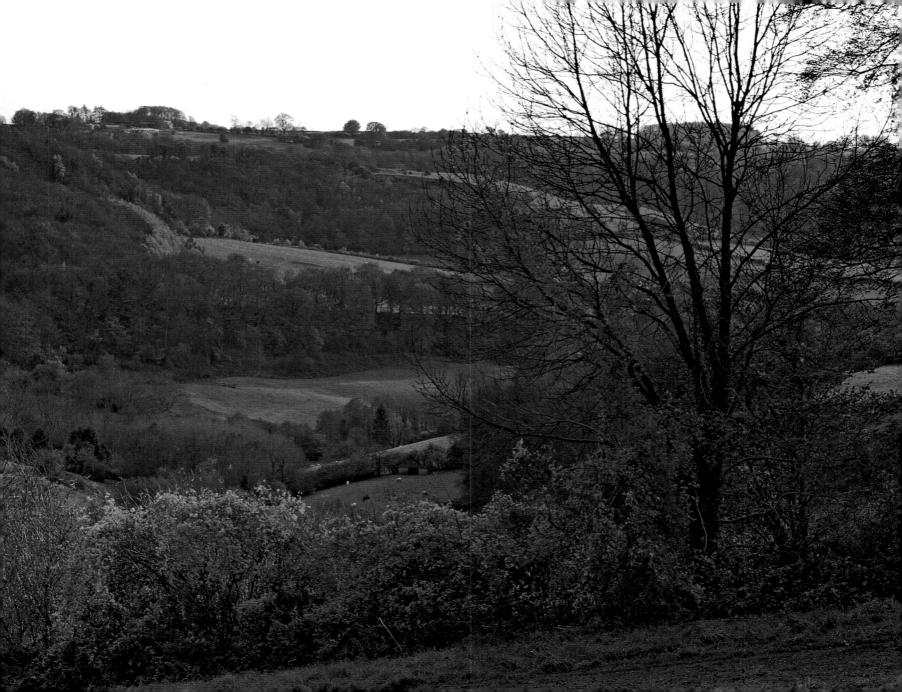

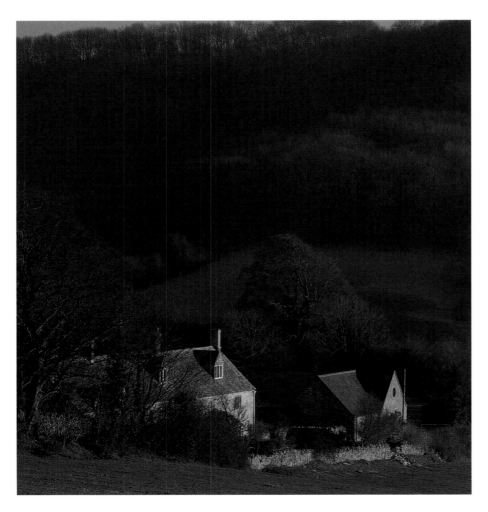

My nostrils are stinging with blossoms of winter
My tongue holds a wafer of tasteless snow.
The landscape abroad is as dark as a cloister
Carved like a run and cracked with blue fern.

December Dawn

. . .

One of the casualties of ubiquitous central-heating in our
homes, probably not regretted but once a source of delight
and wonder to children, is the fern-art of Jack Frost; the
intricate fronded patterns of ice on the inside of the bed-
room windows on a wintry morning.

The first light shakes on the frost-webbed window
Green as a laurel and thick as the sea.

December Dawn

Left: Down Cottage.
Right: Rose Bank, Slad.

70

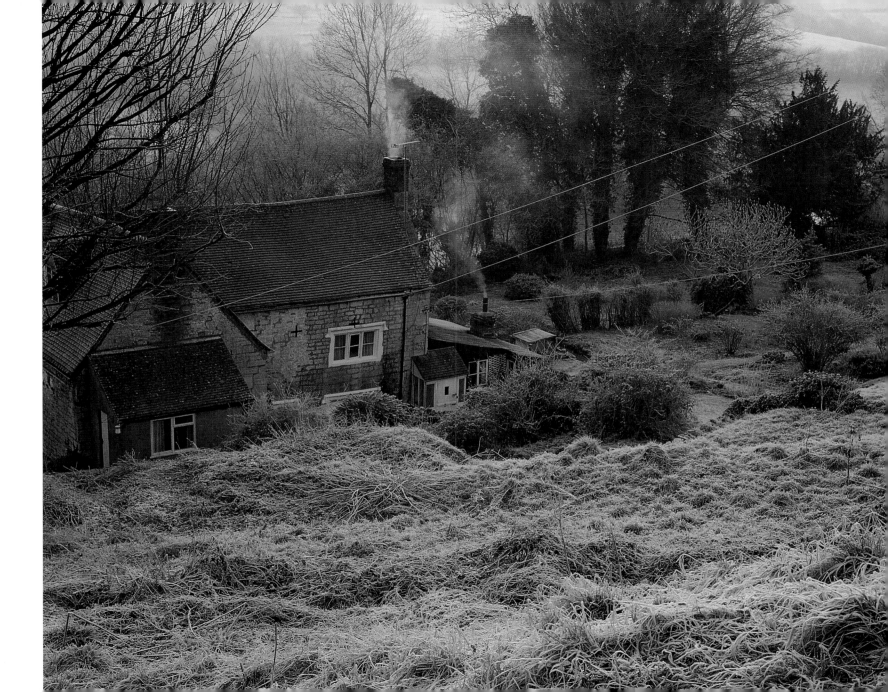

Tonight has no moon,
no food for the pilgrim;
the fruit tree is bare,
the rose bush a thorn
and the ground bitter with stones.

Christmas Landscape

. . .

No night could be darker than this night,
no cold so cold,
as the blood snaps like a wire,
and the heart's sap stills,
and the year seems defeated.

Twelfth Night

. . .

[But] soon the primrose sun will show
and burn with sparking trumpet flowers
this winter's flag of truce.

Winter, 1939–1940

Left: *Twyning's Grove*
Right: *Snowdrops.*

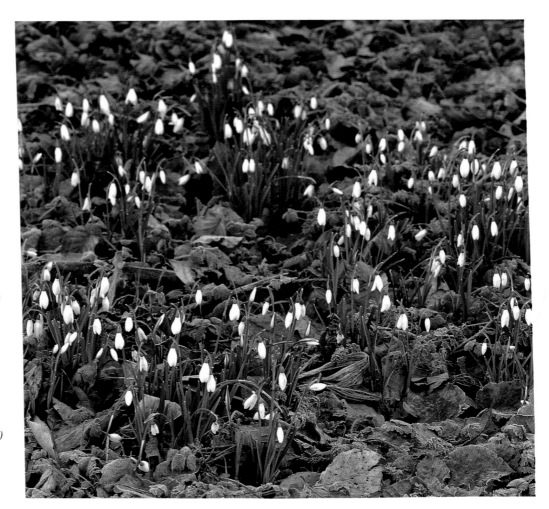

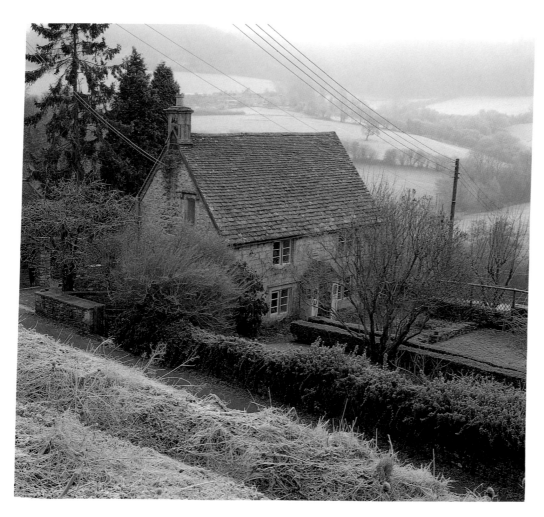

Winter was no more typical of our valley than summer, it was not even summer's opposite; it was merely that other place. The day came suddenly when all details were different and the village had to be rediscovered. Outside ... there was a strange, hard silence, or a metallic creaking, a faint throbbing of twigs and wires.

. . .

It was a world of glass, sparkling and motionless. Vapours had frozen all over the trees and transformed them into confections of sugar.

Left: Rose Cottage, rented by Lee as an adult.
Right: Frosty grass, The Scrubs.

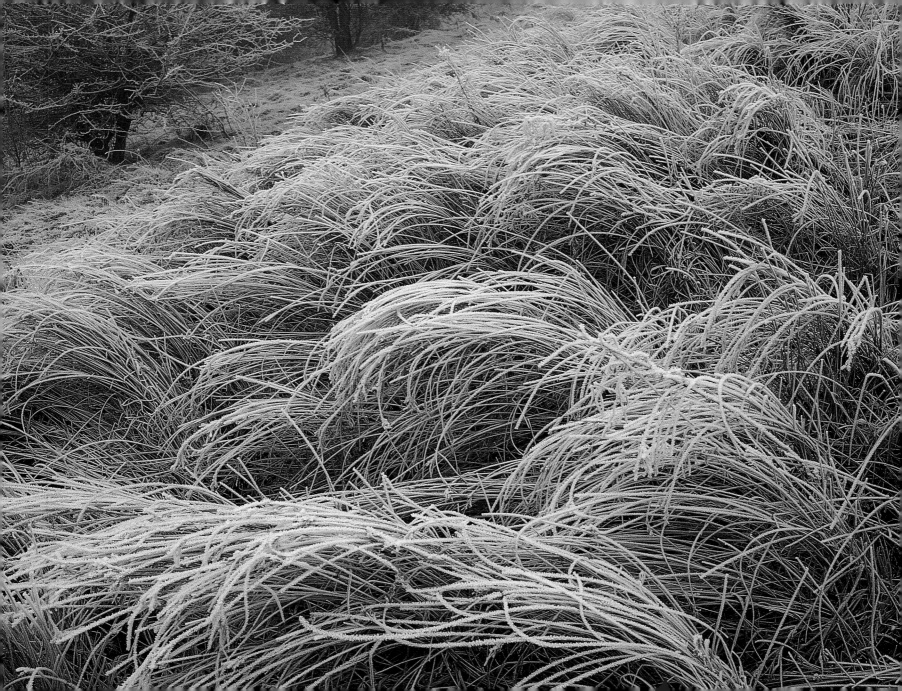

The farmyard muck was brown and hard, dusted with frost like a baked bread pudding.

. . .

The church clock had stopped and the weather-cock was frozen, so that both time and the winds were stilled; and nothing, we thought, could be more exciting than this; interference by a hand unknown, the winter's No to routine and laws – sinister, awesome, welcome.

Left: Cow shed at Haresfield.
Right: St Mary's Church, Painswick.

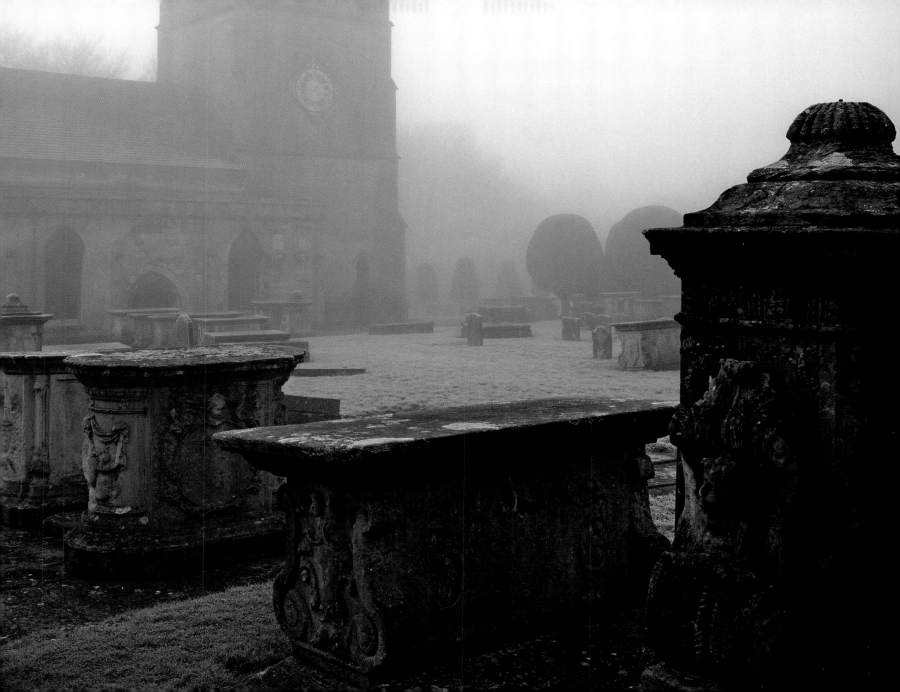

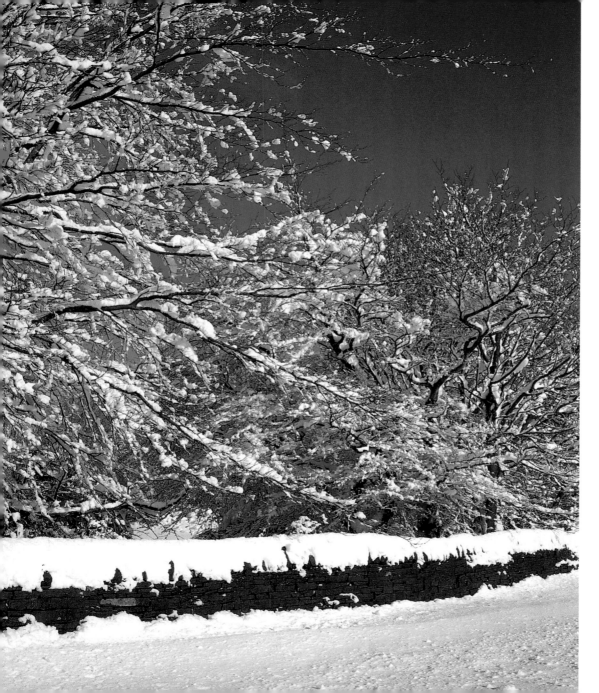

Later, towards Christmas, there was heavy snow, which raised the roads to the top of the hedges. There were millions of tons of the lovely stuff, plastic, pure, all-purpose, which nobody owned, which one could carve or tunnel, eat, or just throw about.

Left: Longridge.

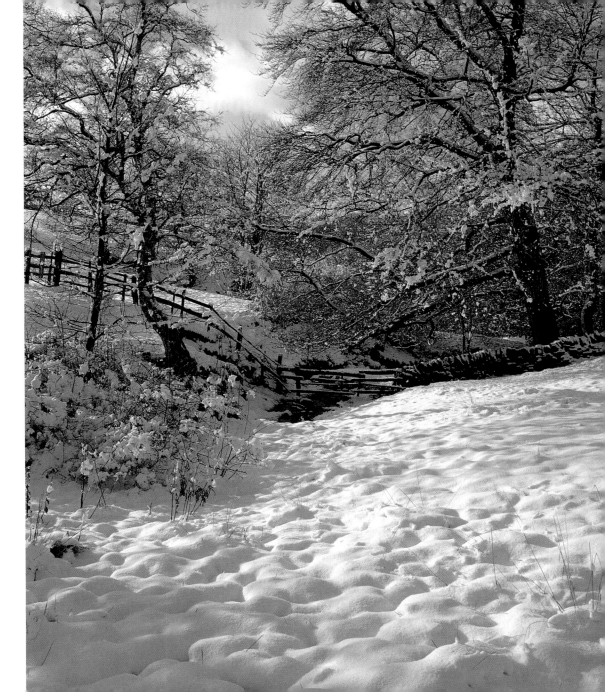

It covered the hills and cut off the
villages, but nobody thought of rescues;
for there was hay in the barns and flour
in the kitchens, the women baked bread,
the cattle were fed and sheltered – we'd
been cut off before, after all.

Right: Slad Brook.

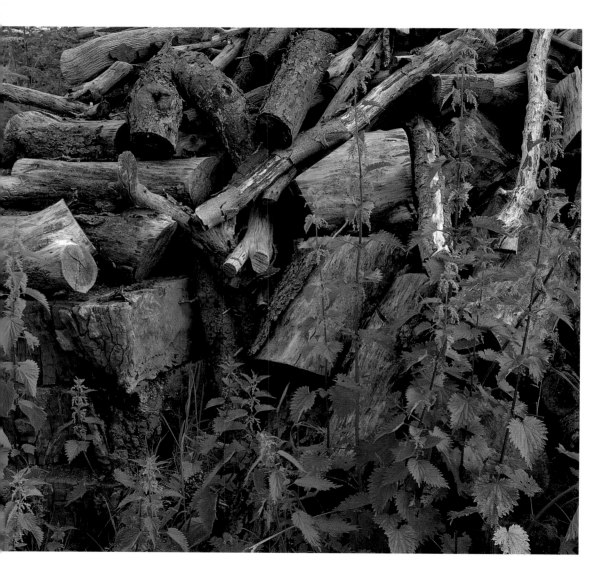

Gathering winter fuel was not just a phrase traditionally carolled at Christmas, but a regular task for Laurie and his brothers. Indeed, the fire and the range had to be stoked all the year round.

The day was over and we had used it, running errands or prowling the fields. When evening came we returned to the kitchen, back to its smoky comfort, in from the rapidly cooling air to its wrappings of warmth and cooking.

Left: *Winter fuel.*

We chopped wood for the night and carried it in; dry beech sticks as brittle as candy ... The state of our fire became as important to us as it must have been to a primitive tribe. When it sulked and sank we were filled with dismay; when it blazed all was well with the world; but if – God save us – it went out altogether, then we were clutched by primeval chills. Then it seemed that the very sun had died, that winter had come for ever, that the wolves of the wilderness were gathering near, and that there was no more hope to look for ...

Right: Logs with moss, Longridge Woods.

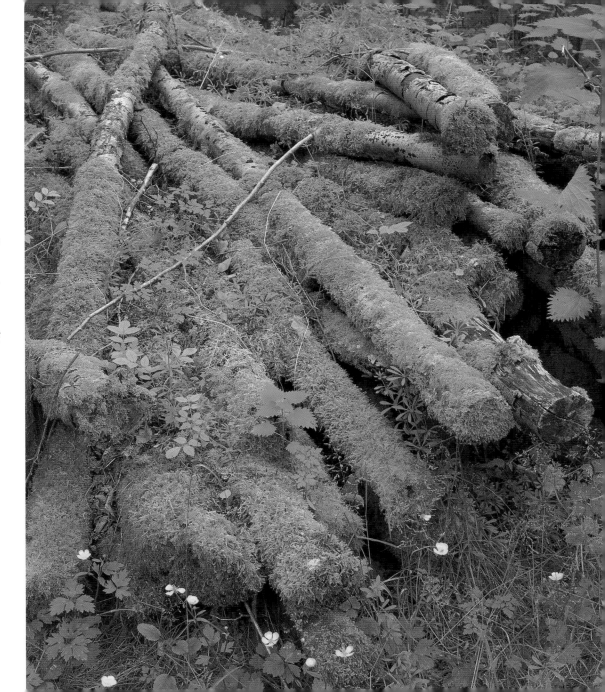

In scenes from the more genial times of the year, flowers formed a permanent backcloth. On the very day of their arrival in Slad, ignoring the cartloads of furniture, while the girls fed Laurie and themselves by stripping the garden of berried fruit, their mother was filling the house with armfuls of flowers.

My mother would grow roses with each hand,
drawing them forth from country-frothing air.

Draw them, shape them, cut them from the thorn;
lay them like bleeding shells about the house.

And with my ears to the lips of those shell-roses
I harked to their humming seas, secret as hives.
And with my lips to those same rose-shell ears
I spoke my crimson words, my stinging brain.

With lips, ears, eyes, and every finger's nerve,
I moved, moth-throbbing, round each creviced fire.

As I do now, lost mother, country gone,
groping my grief around your moss-rose heart.

Moss-Rose

Left: *Wild dog roses.*

83

Mother's father had a touch with horses;
she had the same with flowers. She
could grow them anywhere, at any time,
and they seemed to live longer for her.
She grew them with rough, almost slap-
dash love, but her hands possessed such
an understanding of their needs they
seemed to turn to her like another sun.

. . .

She could snatch a dry root from field or
hedgerow, dab it into the garden, give
it a shake – and almost immediately it
flowered. One felt she could grow roses
from a stick or chair-leg, so remarkable
was this gift.

Left: Lane at Dunkitehill.
Right: Saltbox.

Our terraced strip of garden was
Mother's monument, and she worked
it headstrong, without plan. She would
never control or clear this ground,
merely cherish whatever was there;
and she was as impartial in her
encouragement to all that grew as a spell
of sweet sunny weather.

· · ·

She would force nothing, graft nothing,
nor set things in rows; she welcomed
self-seeders, let each have its head, and
was the enemy of very few weeds.
Consequently our garden was a sprouting
jungle and never an inch was wasted.

Left: Cottage garden, Slad.
Right: Snow's Farm.

Often some species would entirely capture the garden – forget-me-nots one year, hollyhocks the next, then a sheet of harvest poppies. Whatever it was, one let it grow.

. . .

Such a chaos of blossom as amazed the bees and bewildered the birds in the air. Potatoes and cabbages were planted at random among foxgloves, pansies and pinks.

Left: Sweet peas.and runner beans
Right: Cottage, Painswick.

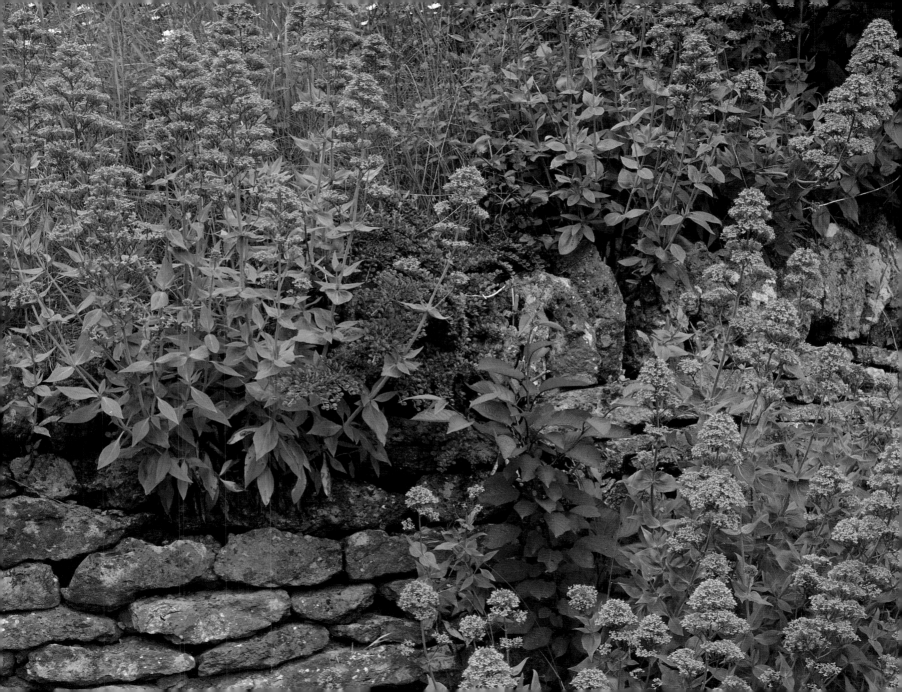

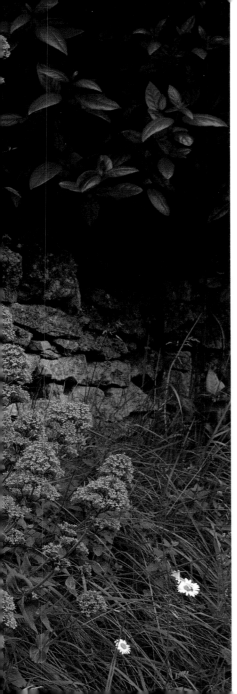

… Mother went creeping around the
wilderness, pausing to tap some odd bloom
on the head, as indulgent, gracious, amiable
and inquisitive as a queen at an orphanage.

Left: Wall with Valerian.

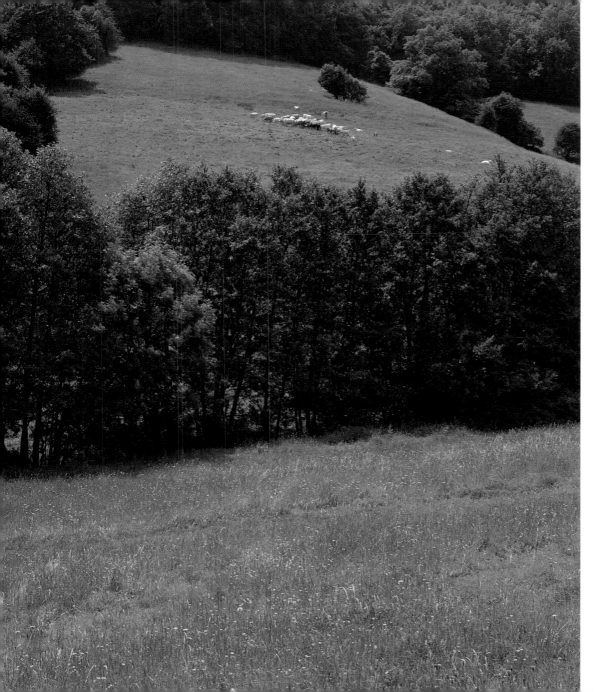

The new woods rising in Horsley now, in Sheepscombe, in Rendcombe and Colne, are the forests my Uncle Charlie planted on thirty-five shillings a week. His are those mansions of summer shade, lifting skylines of leaves and birds, those blocks of new green now climbing our hills to restore their remembered perspectives.... Uncle Charlie has left a mark on our landscape as permanent as he could wish.

Left: Cows in pasture, Catswood.
Right: The Frith.

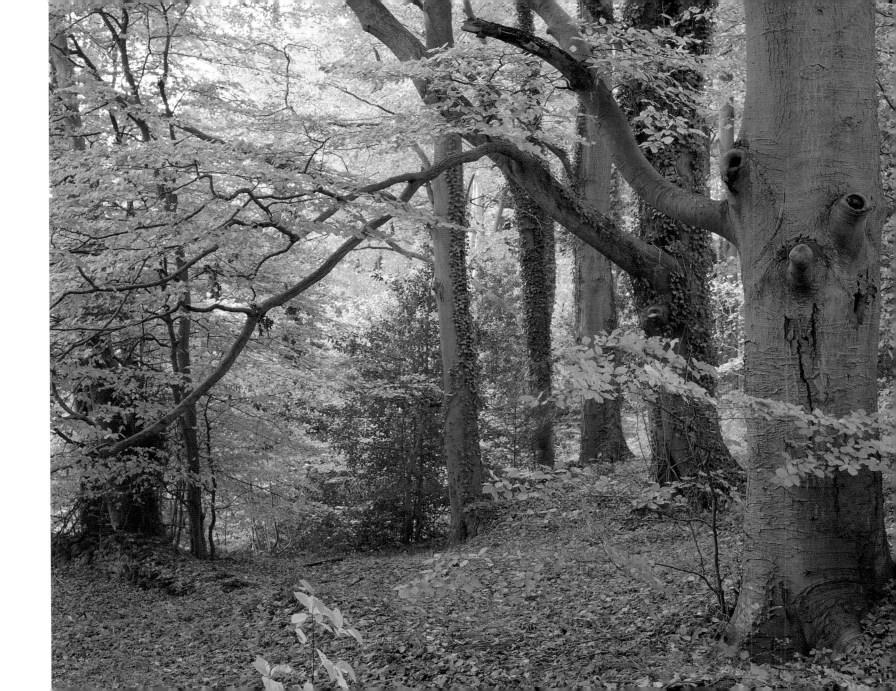

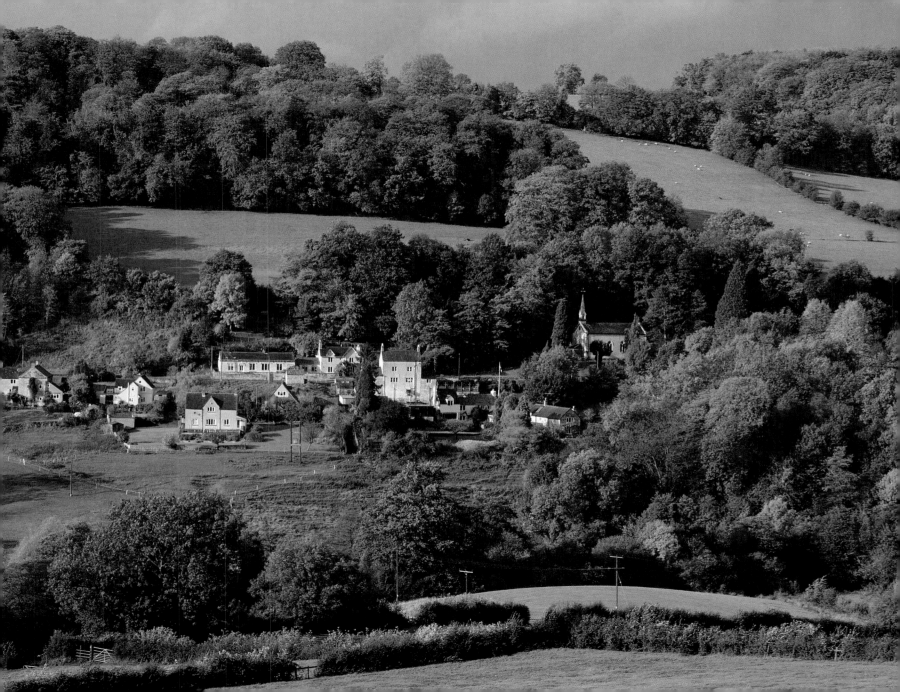

The sides of the valley were rich in pasture
and the crests heavily covered in beechwoods.
Our horizon of woods was the limit of our
world. For weeks on end the trees moved in
the wind with a dry roaring that seemed a
natural utterance of the landscape.

. . .

O the wild trees of my home ...
In winter they ringed us with frozen spikes ...

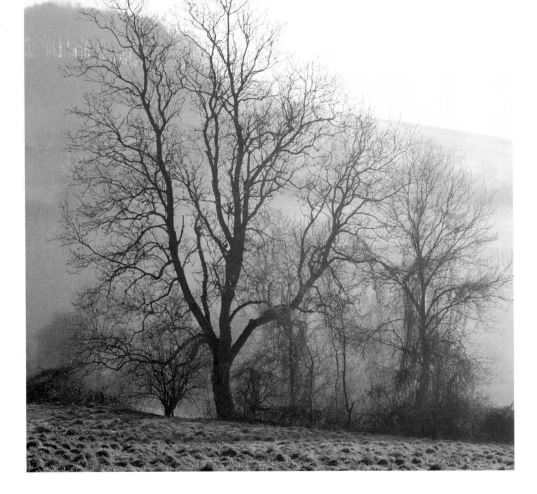

Left: *Slad from Swift's Hill.*
Right: *Down Hill.*

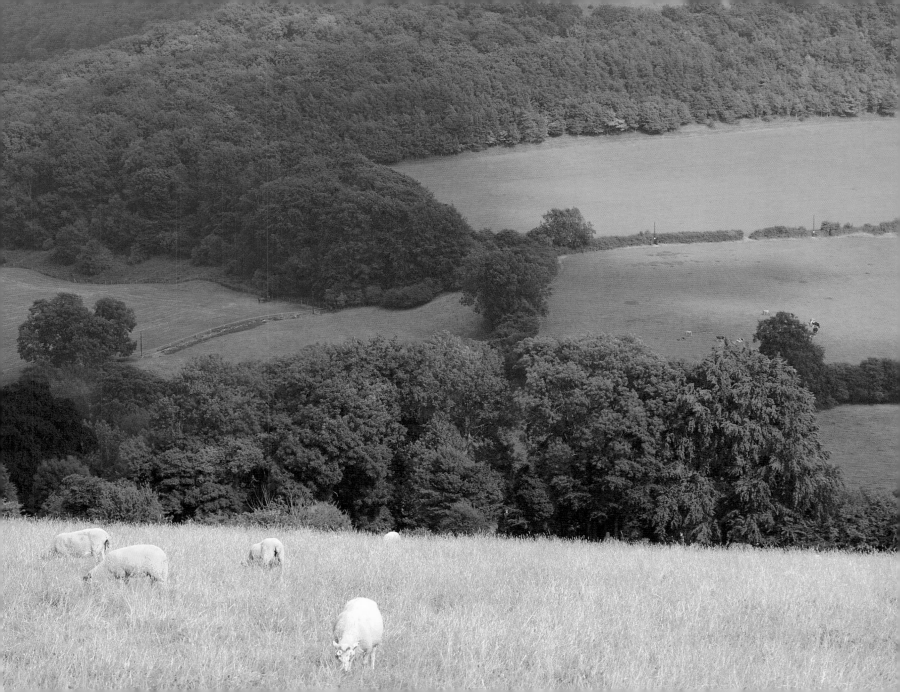

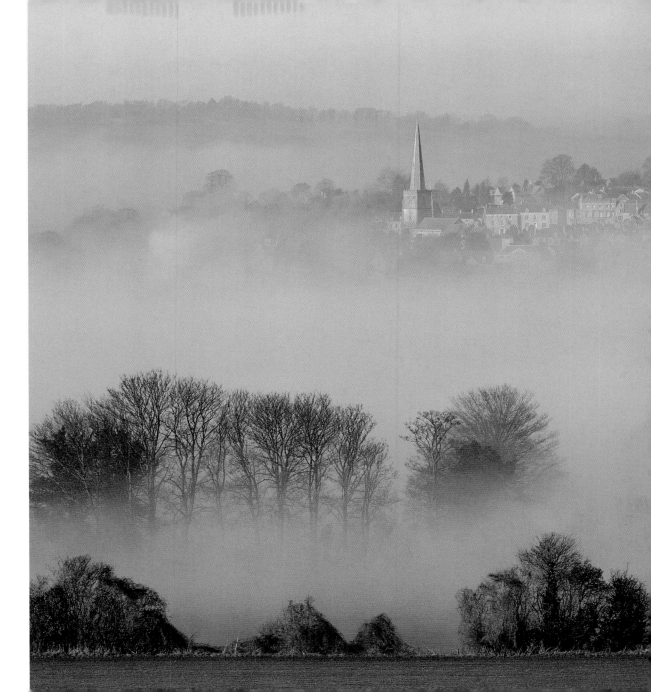

… and in summer they oozed over the lips of the hills like layers of thick green lava.

. . .

Mornings, they steamed with mist or sunshine …

Left: *View of Slad Valley from Juniper Hill.*
Right: *View of Painswick.*

... and almost every evening
threw streamers above us,
reflecting sunsets we were too
hidden to see.

Right: *Painswick at dusk.*

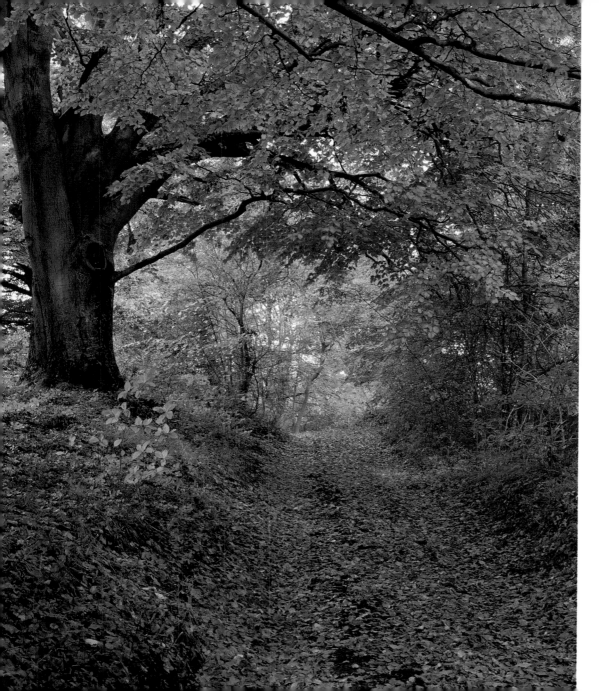

Woods can be sinister places. They have atmospheres of their own and whiffs of ancient, pagan deities. The valley woods were no exception, from Deadcombe Bottom below Bulls Cross Heath, to those at Catswood. The former surrounded the decaying hangman's cottage where Laurie and his mates played, undeterred by its gruesome hook. (On this the wretched mechanic had finally exercised his skill on himself, driven demented by the terrible revenge of the villagers.) The latter sheltered a two-headed sheep.

Left: The Frith.
Right: Blackstone Wood.

There is little remarkable about a two-headed sheep, except this one was old and talked English. It lived alone among the Catswood larches, and was only visible during flashes of lightning. It could sing harmoniously in a double voice and cross-question itself for hours; many travellers had heard it when passing that wood, but few, naturally enough, had seen it. And when the sheep-lightning flickered over the Catswood trees it was thought best to keep away from the place.

Left: Grass meadow at Catswood.

The Bulls Cross Coach was another ill omen, and a regular midnight visitor. Bulls Cross was a saddle of heathland set high at the end of the valley, once a crossing of stage-roads and cattle-tracks which joined Berkeley to Birdlip, and Bisley to Gloucester-Market. Relics of the old stage-roads still imprinted the grass as well as the memories of the older villagers. And up here, any midnight, but particularly New Year's Eve, one could see a silver-grey coach drawn by flaring horses thundering out of control, could hear the pistol crack of snapping harness, the screams of the passengers, the splintering of wood, and the coachman's desperate cries. The vision recalled some ancient disaster, and was rehearsed every night, at midnight.

Right: *Path through grass meadow, Bulls Cross.*

As for Bulls Cross – that ragged wildness of bent turves – I still wouldn't walk there at midnight. It was a curious tundra, a sort of island of nothing set high above the crowded valleys. Yet its hollows and silences, bare of all habitations, seemed stained by the encounters of strangers. At this no-man's crossing, in the days of foot-pads and horses, travellers would meet in suspicion, or lie in wait to do violence on each other, to rob or rape or murder. To the villagers around, it was a patch of bare skyline, a baldness among the woods, a wind-scarred platform which caught everybody's eye, and was therefore just the place for a gibbet. A gibbet, consequently, had stood there for years, which the old folk could still remember.

Right: *Iron bench at Bulls Cross.*

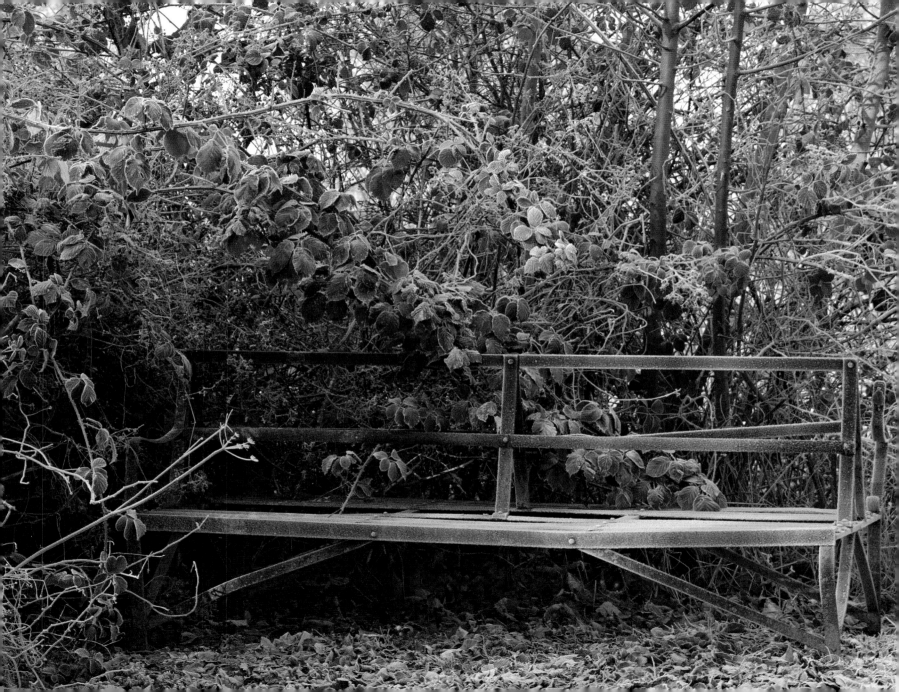

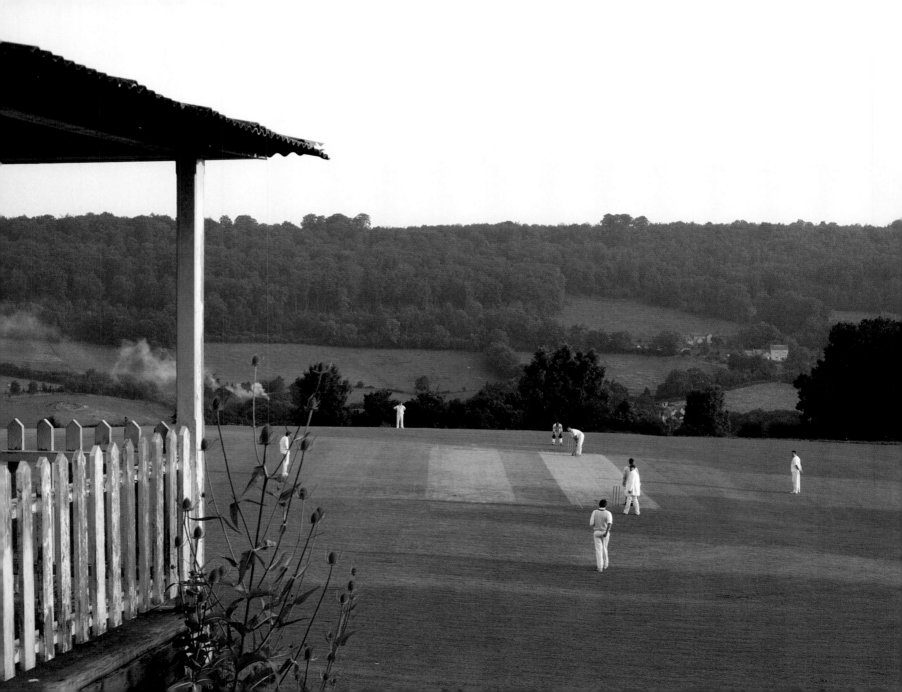

Other, flesh and blood, eccentrics haunted the village; disquieting characters with names such as Cabbage-Stump Charlie, Willy the Fish, Fisty Fill, Albert the Devil, Tusker Tom, Harelip Harry and the Prospect Smiler. Childhood friends were no less capriciously styled. Fellow choristers included Horace and Boney, Clergy Green, Walt the Bully and Sixpence the Tanner. Sixpence was a particular friend and, with his lame brother Sammy, an enthusiastic cricketer.

… we retired to the paddock and played cricket under the trees. Sammy, in his leg-irons, charged up and down. Hens and guinea fowl took to the trees. Sammy hopped and bowled like murder at us, and we defended our stumps with our lives. The cracked bat clouting; the cries in the reeds; the smells of fowls and water; the long afternoon with the steep hills around us … where it was summer, in some ways, always.

Some years later, at his eightieth birthday party, as the Woolpack pub's Cricket XI was playing Sheepscombe, Laurie Lee presented Sheepscombe C.C. with the keys of their pavilion (which he had paid for) and bought pints all round. Years before he had bought the cricket ground where his forebears had played for three generations and preserved it from 'development'. As he eulogized, 'It is one of the real classic cricket grounds with one of the best views in Gloucestershire.'

Left: *Sheepscombe Cricket Club.*

On occasion the entertainment was organized and official. Is Recreation Cottage built on the site of the vanished village Hut, where so much of it took place? Hall of Varieties for the Slad Players, dancehall for penny hops, venue for whist drives, billiards, darts and dominoes, for village gossip and mothers' meetings, the Hut housed them all in turn. Then there were 'Outings'. Evolving through farm-wagon and horse-brake, the new power of the motor charabanc allowed Outings of a previously unknown scale.

Right: *Recreation Cottage, Slad.*

One year the [choir] Outing was to Weston–super–Mare, and we had saved up for months to be worthy of it. We spent the night before preparing our linen, and the girls got up at dawn to make sandwiches. The first thing I did when I came down that morning was to go out and look at the weather. The sky was black, and Tony was behind the lavatory praying hard through his folded hands.

Left: Downhill Mound.

The vicar arrived to see us off – his pyjamas peeping out from his raincoat. He issued each choirboy with his shilling for dinner, then dodged back home to bed. The last to turn up was Herbert the gravedigger, with something queer in a sack …

. . .

In our file of five charabancs, a charioted army, we swept down the thundering hills. At the speed and height of our vehicles, the whole valley took on new dimensions; woods rushed beneath us, and fields and flies were devoured in a gulp of air.

Right: *View of Snow's Farm and Piedmont.*

We were windborne now by motion and pride, we cheered everything, beast and fowl, and taunted with heavy ironical shouts those unfortunates still working in the fields. We kept this up till we had roared through Stroud, then we entered stranger's country. It was no longer so easy to impress pedestrians that we were the Annual Slad Choir Outing.

Left: *The Shambles, Stroud.*
Right: *Town Hall Offices, Stroud.*

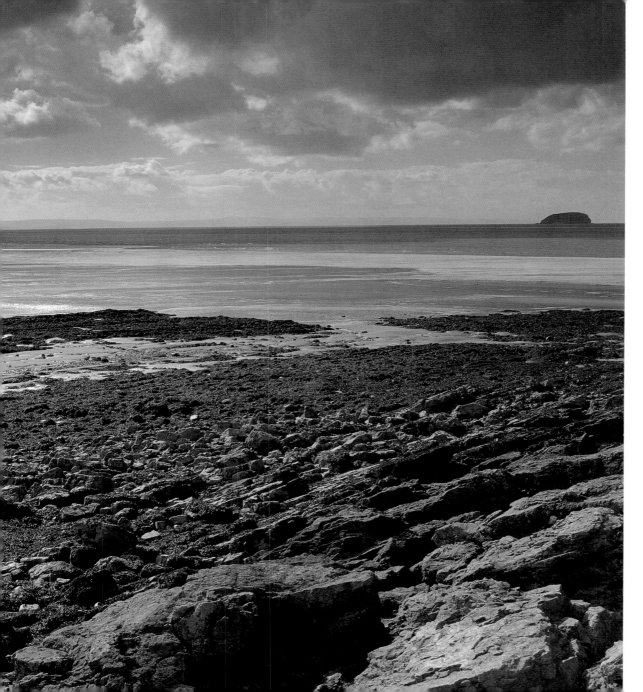

'The seaside,' they said: we gazed around us, but we saw no sign of the sea. We saw a vast blue sky and an infinity of mud stretching away to the shadows of Wales.

Left: Low tide at Weston-Super-Mare.

But rousing smells of an invisible ocean astonished our land-locked nostrils: salt, and wet weeds, and fishy oozes; a sharp difference in every breath.

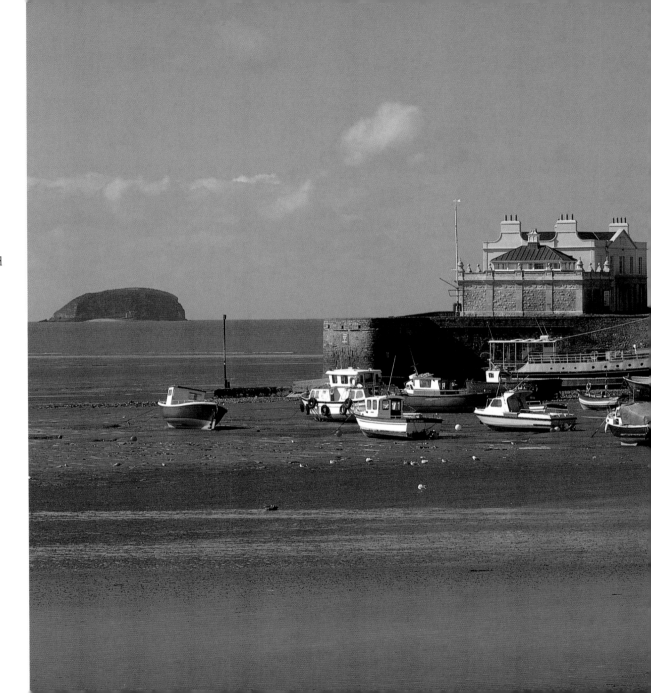

Right: The harbour and Steep Holm.

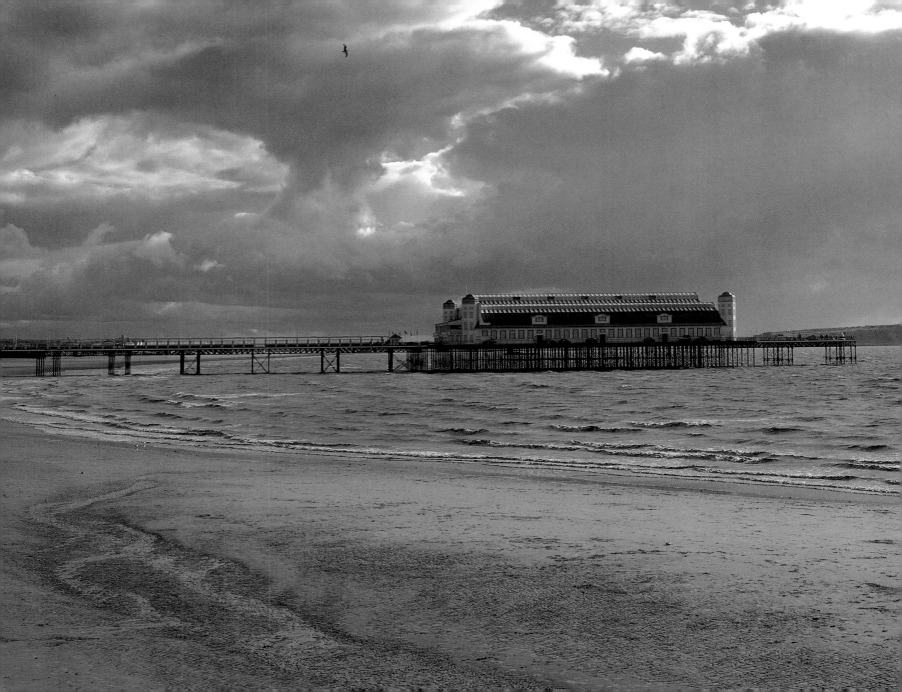

… we had never seen such openness, the blue windy world seemed to have blown quite flat, bringing the sky to the level of our eyebrows.

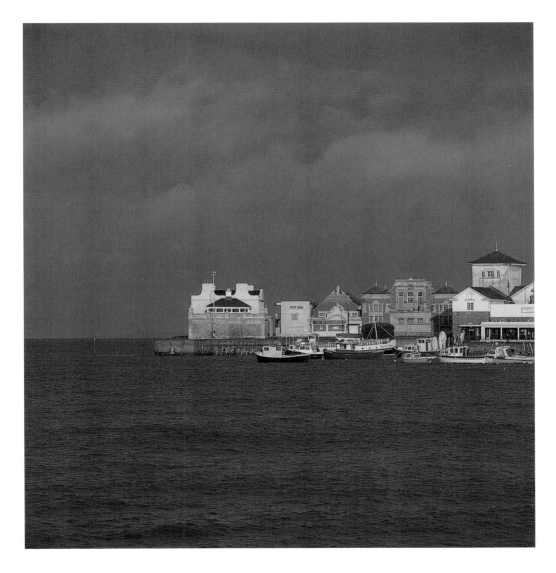

Left: The Grand Pier.
Right: The harbour at dawn.

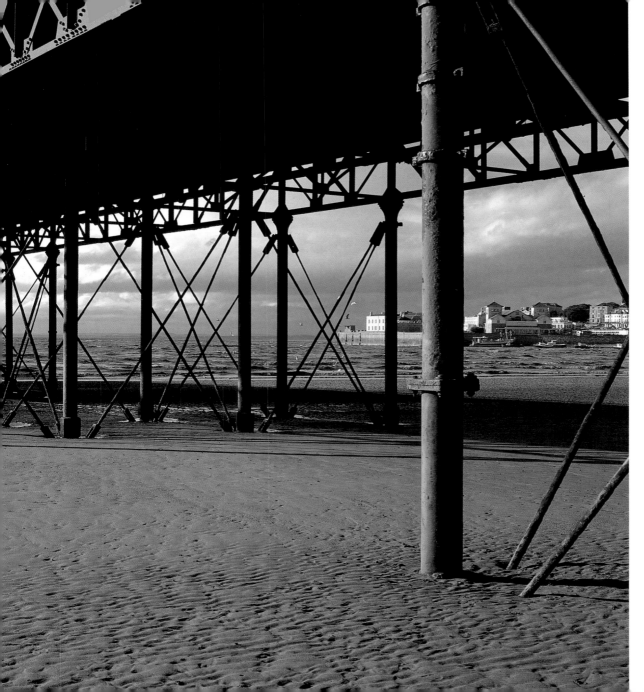

Canvas booths flapped on the edge of the Prom, mouths crammed with shellfish and vinegar; there were rows of prim boarding-houses (each the size of our Vicarage); bath–chairs, carriages and donkeys …

. . .

… and stilted far out on the rippled mud a white pier like a sleeping dragon.

Left: Weston-Super-Mare, the Grand Pier.
Right: Marine Parade from Anchor Head.

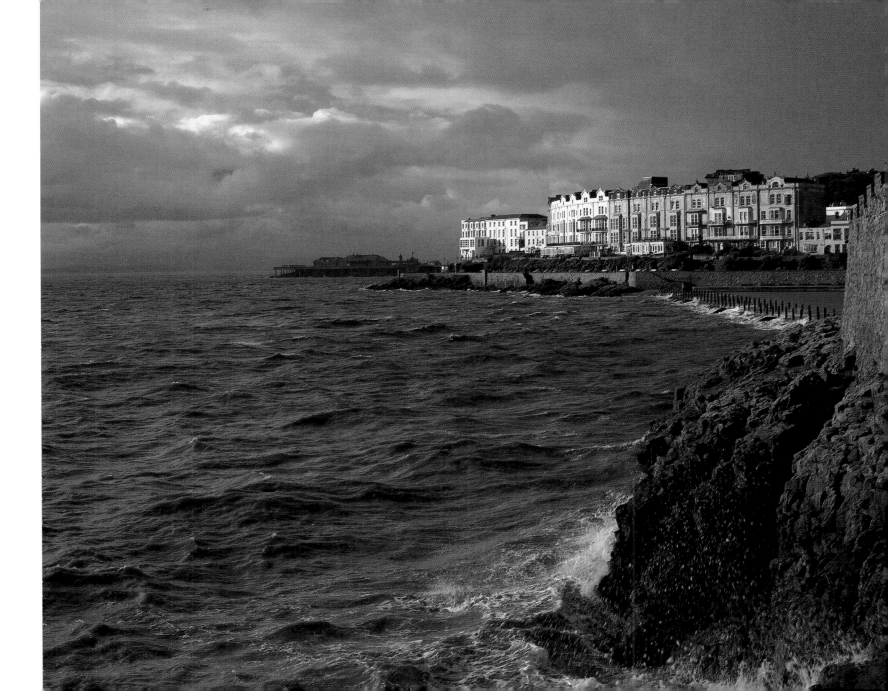

Magic construction striding the waves, loaded
with freaks and fancies, water chutes and crumpled
mirrors, and a whole series of nightmares for a
penny. One glided secretly to one's favourite
machine, the hot coin burning one's hand, to
command a murder, a drunk's delirium, a haunted
grave, or a Newgate hanging. The last, of course,
was my favourite.

Right: The Grand Pier at dusk.

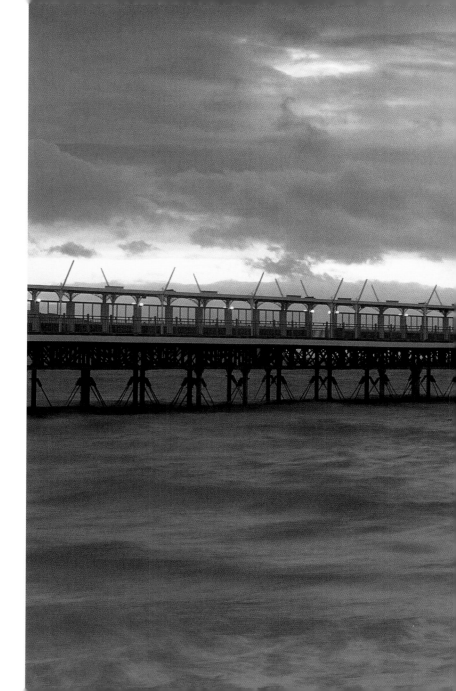

All villages have their tragedies which in time become part of lore and legend. An anguished Fred Bates, late with the milk one Sunday morning, brought the news of the village Ophelia to the family.

He'd been coming from milking; it was early, first light, and he was just passing Jones's pond. He'd stopped for a minute to chuck a stone at a rat – he got tuppence a tail when he caught one.

Down by the lily-weeds he suddenly saw something floating. He'd thought at first it was a dead swan ... but when he went down closer, he saw, staring up at him, the white drowned face of Miss Flynn.

· · ·

This was the pond that had choked Miss Flynn. Yet strangely and not by accident. She had come to it naked, alone in the night, and had slipped into it like a bed; she lay down there, and drew the water over her, and drowned quietly away in the reeds. I gazed at the lily roots coiled deep down, at the spongy weeds around them. That's where she lay, a green foot under, still and all night by herself, looking up through the water as though through a window and waiting for Fred to come by.

Right: *Jones's Pond.*

A wasting memory is not only a destroyer; it can deny one's very existence. A day unremembered is like a soul unborn, worse than if it had never been.

In writing my first volume of autobiography, *Cider with Rosie*, I was moved by several needs, but the chief one was celebration: to praise the life I'd had and so preserve it, and to live again both the good and the bad.

The end of my childhood also coincided by chance with the end of a rural tradition – a semi-feudal way of life which had endured for nine centuries, until war and the motor-car put an end to it ...

My own story would keep, whereas the story of the village would not, for its words, even as I listened, were being sung for the last time and were passing into perpetual silence.

Writing Biography

Left: Rose Cottage.
Right: Trillgate Cottage, Down Hill.

126

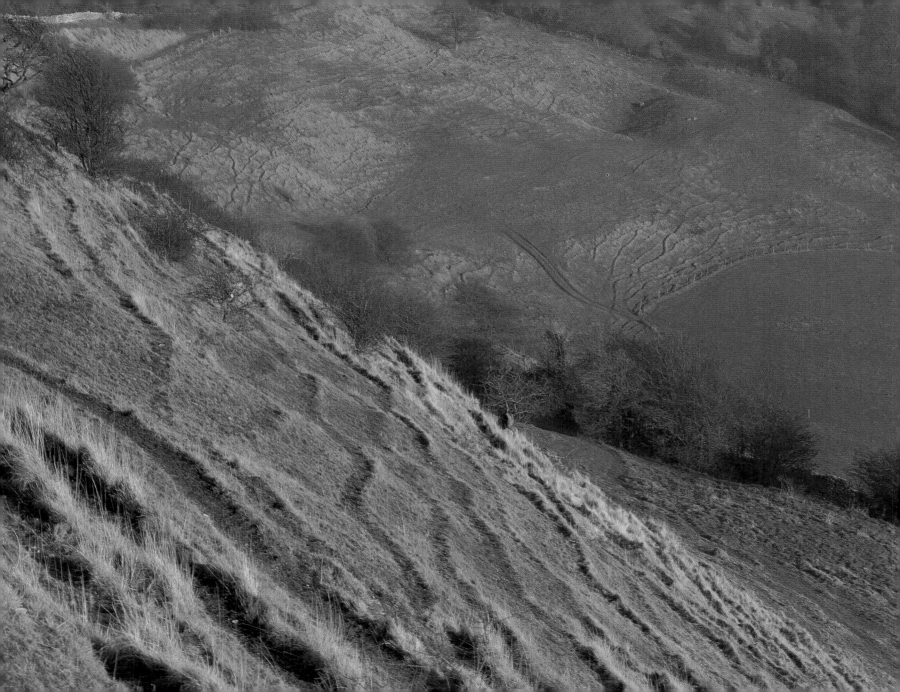

Twice a year Laurie used to climb to the top of the one-thousand-foot-high Haresfield Beacon, which magnificently surveys the Severn Plain.

It was an Iron Age fort, strategically so unique that it must have been where the local tribes took refuge when the wild Welsh came over the river and tried to attack their flocks and chicken and women. I go up there to see the sunset on the longest day, the 21st of June, and on the shortest day, the 21st of December. I'm fascinated by the movement of the sun in relation to our valleys.

At the winter solstice the sun sets in mid-afternoon, but in June, from this exalted height, it would be quite late at night.

It's a magical experience, but of course it's mixed with melancholy because that is your longest day. From then on, we're for the dark.

BBC Interview, 1988

Left: *View from Haresfield Beacon.*

'So do I breathe the hayblown airs of home …' wrote Laurie in the poem Home from Abroad. *'My heart's keel slides to rest among the meadows.' Haymaking was a seasonal toil for men and boys and cider was traditionally brewed by all farms to refresh the farmhands. Fletcher's fields on Swift's Hill where the young Laurie raked and forked were overlooked by his study when, a celebrated writer, he moved back to his original cottage. But who was the eponymous Rosie? There are one or two claimants, although her author maintained she was a composite. In truth she's an immortal and it's better not to know.*

Right: *Knapp Farm from Swift's Hill.*

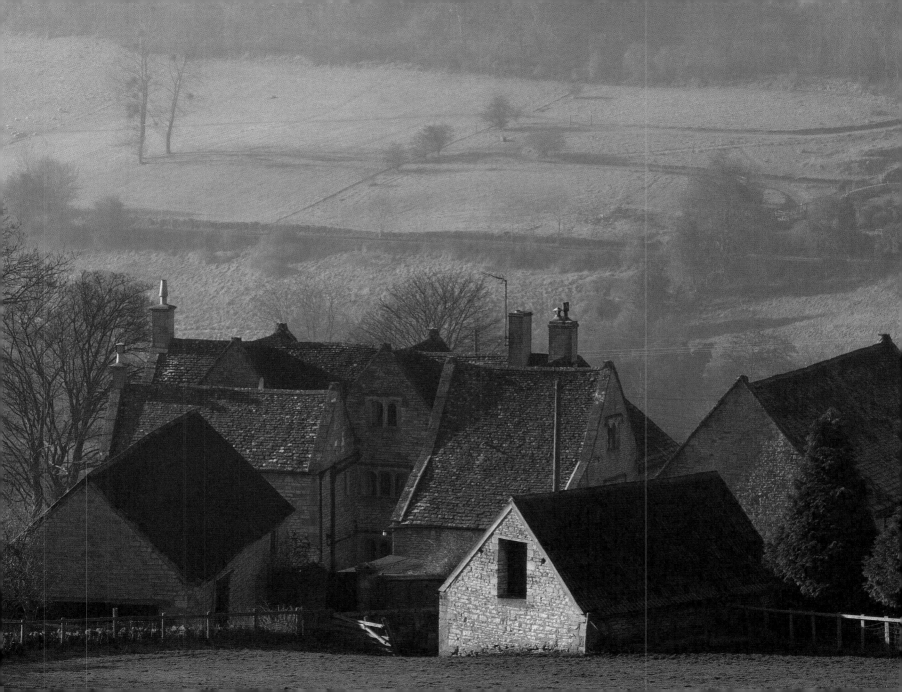

The day Rosie Burdock decided to take me in hand was a motionless day of summer, creamy, hazy, and amber coloured, with the beech trees standing in heavy sunlight as though clogged with wild wet honey. It was the time of haymaking ...

. . .

Never to be forgotten, that first long secret drink of golden fire, juice of those valleys and of that time, wine of wild orchards, of russet summer, of plump red apples, and Rosie's burning cheeks.

Left: *Wild flowers at Bulls Cross.*
Right: *Cider press at Down Farm.*

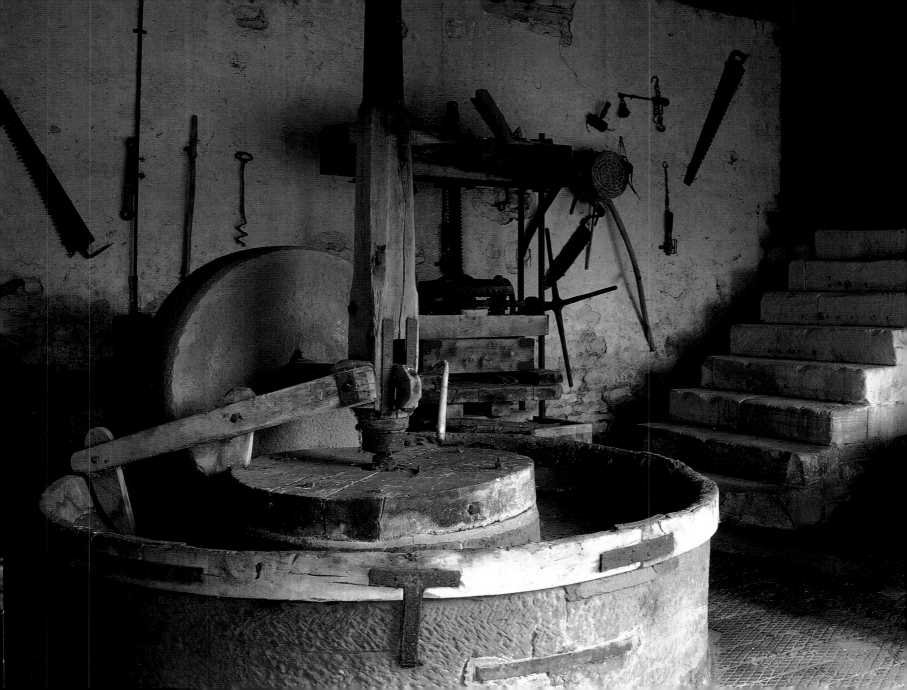

EPILOGUE

Walking the abandoned shade
of childhood's habitations,
my ears remembering chime,
hearing their buried voices.

Hearing original summer,
the birdlit banks of dawn,
the yellow-hammer beat of blood
gilding my cradle eyes.

Hearing the tin-moon rise
and the sunset's penny fall,
the creep of frost and weep of thaw
and bells of winter robins.

Hearing again the talking house
and the four vowels of the wind,
and midnight monsters whispering
in the white throat of my room.

Season and landscape's liturgy,
badger and sneeze of rain,
the bleat of bats, and bounce of rabbits
bubbling under the hill;

Each old and echo-salted tongue
sings to my backward glance;
but the voice of the boy, the boy I seek,
within my mouth is dumb.

The Abandoned Shade

Right: *Rose Bank, Slad.*

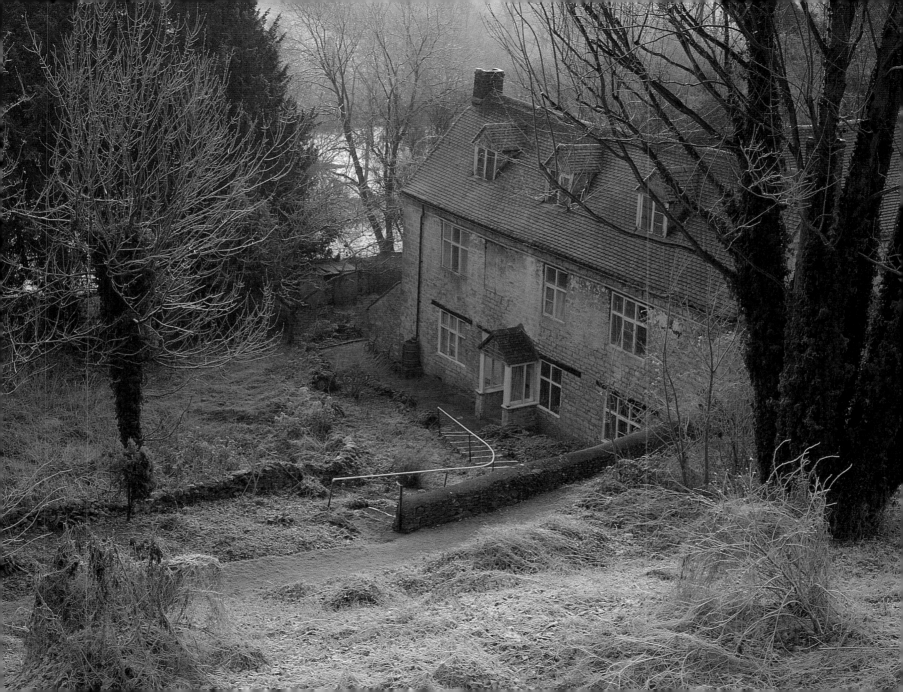

Laurie Lee died in Slad in 1997, eighty years after he had first arrived there as a small child, plonked from the Carrier's Cart into the June grass. At the age of nineteen he left the valley of these pages, but after continuous tugging, it finally drew him back nearly three decades later. As he put it, he had left 'a turnip-faced grinning oaf' and returned 'a bag-eyed poet who had written a book about them all and broken taboos.' His adventures in-between and the family and friends who cherished him up to the end may be met elsewhere. Suffice it to say that he lies where he wished, in the older, lower churchyard; 'between the pub and the church, so that I can balance the secular and the spiritual, and my long sleep will be punctuated by rowdy Saturday nights in the Woolpack, and Sunday morning worship in the church. It would give me a feeling of continuity.'